Shady Pines
Padstow, Cornwall

A Complete-Care Asylum/Spa & Fish Mongery

To: Our Well Esteemed Publisher
From: Froud and Berk

Re: Goblins!

DO NOT PRINT THIS BOOK.

As well you know, we set out to study the many and untidy machinations of the Goblin world. In this matter, we have most certainly succeeded, though at a terrible price. Through the use of the dubious Goblin Camera, recent translations from the corrupt Codex Goblinensis, and "help" from our highly unreliable captured Goblin informant, we have discovered that ~~the most~~ ~~spoiled~~ but we were fools.

All the while as we studied them, the Goblins using us as dupes. Never have we ~~danced the Goblin should dance~~ ~~intrustion.~~

SUCH BIG LIARS are their creatures.

BURN THIS MANUSCRIPT.

We beg you

to forgive us. we mean, "Do not print this book TODAY." Tomorrow FINE. So many pretty pretties. Mortal world will soon ~~BE OURS~~ enjoy reading about sweet pretty GOBLINS who love them too much.

THANK Yew.

Froud ~~Face~~ and Berk ~~Head~~

∼ DISCLAIMER ∼

THE PUBLISHER CAN ACCEPT NO RESPONSIBILITY WHATSOEVER FOR ANY PROBLEMS ARISING FROM THE PURCHASE OR CASUAL PERUSAL OF THIS WORK.

The manuscript of this book arrived (late) in a confusing heap and we have done our best to render some sense of it. Since its arrival, we have been unable to reach the authors, Mssrs. Froud and Berk, who are, we understand, in hiding. Ultimately, we decided that it would be best to present the work "as is," only supplying some much needed headings for the four different parts. Through their assistant, a very helpful Mr. N. Yargle, we have received some last-minute updates and have duly included them in Part 4. This being done, we now wash our hands of the whole sordid business and present this book to you with our sincerest apologies.

This book is dedicated to Robert and Jeremy.
They know why.

ACKNOWLEDGMENTS

Despite their extraordinary and quite sensible efforts to prevent the publication
of this timely but scurrilous work, we would like to thank the following:

Kris and Wendy for their good sense in the face of nonsense; our agent, Muriel Nellis, and her team
at Literary and Creative Artists for believing in and promoting our work; our editor, Anne Kostick,
for her many editorial insights and frequent goblin wrangling; Tracy Ford for loan of his sharp eyes;
Robin and Toby for the production of inspiring goblin evidence during their early years; Robert
Gould for total support; and the kind staff of Shady Pines Asylum and Spa for their affectionate
attention to every detail of our recoveries.

Visit the Official Froud Goblins Web site
www.GotGoblins.com

An Imaginosis Book
www.imaginosis.com

Designed by Emiliano Dacanay for Wherefore Art?, London
Art Direction by Brian Froud

Library of Congress Cataloging-in-Publication Data
Froud, Brian and Berk, Ari.
 Brian Froud's Goblins! / interpreted, analyzed, and written by Ari Berk.
 p. cm.
 Includes index.
 ISBN 1-58479-383-X
 1. Froud, Brian. 2. Goblins in art. I. Berk, Ari. II. Title.

NC978.5.F76A4 2004
741.6'42'092--dc22
2004000343

Published in 2004 by Harry N. Abrams, Incorporated, New York
Printed and bound in China
10 9 8 7 6 5 4 3 2 1

Harry N. Abrams, Inc.
100 Fifth Avenue
New York, NY 10011
www.abramsbooks.com

Abrams is a subsidiary of

LA MARTINIÈRE

pages 4 veRy nicE
5 and 7
12 luveRly RUBBISH

GOBLINS!

A SURVIVAL GUIDE AND FIASCO IN FOUR PARTS

Pictures by Brian Froud

Words by Ari Berk

3-D Goblinizations by Wendy Froud

Harry N. Abrams, Inc.
New York

A World of Froud / BerkWerks Production

An IMAGINOSIS Book

87 MAGNiFiCENT!

Introduction

IN WHICH THE STRANGE BEGINNING OF THESE INVESTIGATIONS IS DESCRIBED.

I have enjoyed a long and curious friendship with Brian Froud (a minor, obscure artist who has a very tentative relationship with reason). Recently, however, I became worried about him. I had received strange, anonymous gifts in the mail that could have come only from him: a moldy, origami lobster made of his favorite drawing paper; six pieces of burned toast that, from the lint patterns, had clearly all fallen butter-side down; a broken spurtle.

Then came The Letter (more a postcard, really): small, chewed pieces of paper taped together, with my name and address scrawled upon the front. On the underside were written three words in Brian's handwriting: "Lights. Camera. Goblins!" along with his ardent request, "Bring Codex!" Of course he was referring to the *Codex Goblinensis*, which I had recently unearthed and was currently studying. I quickly noticed that the pieces of paper that made up his postcard seemed to be sections of a larger image, and when I took them apart and reassembled them, the most amazing portrait appeared. The paper was quite brittle, almost ancient seeming, and much stained. As I gazed at the photo, I felt my sanity begin to unravel at the edges. Instantly, I knew that Brian's lifelong investigation into the Faery Realm had reached an apogee. Here, stained, blurred, but undeniable and strangely familiar, was a photograph of a goblin. I packed, and caught the next plane to England.

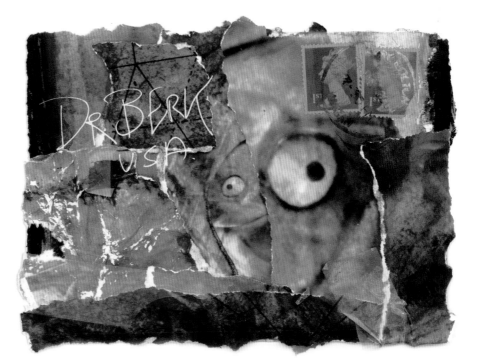

The original postcard >

Mr. Froud in his curious Brackenfrock.
Believed to be the only photograph
actually taken by Goblins themselves.

Mr. Froud's lawyers have requested that it
be clearly understood that Brackenfrocks
are a traditional form of country clothing
worn only by artists of extraordinary talent
and as such are perfectly normal and not
sartorially deviant. **>**

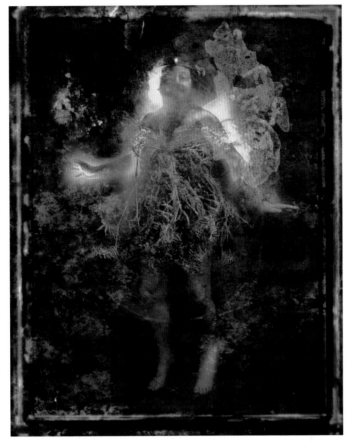

THE CODEX
GOBLINENSIS

Soon after my arrival in Devon, I found Brian, muttering on the moor, covered in nothing but a curious organic frock made entirely of strategically-placed bracken. He was ranting about a camera and the end of the world.

Wrapping him in a sanitized wool blanket I always carry for such occasions, I led him back to his house, where, beside a warming fire, he begged me to show him the *Codex*. The goblins call this mighty book their "Holie Chronicle" or, more commonly, The Sticky Sandwich, a popular goblin colloquialism referring to its enormous (to them), flapping, bread-like covers, between which are stuffed all manner of goblin "meaty bits." I knew it simply as the most remarkable, and certainly the grossest, of my many remarkable discoveries.

Brian was eager to know how I had come by it, and with some embarrassment, I related the tale of its finding. Actually, the book had found me. Several months earlier, I had ordered a copy of a rare fifteenth-century treatise on the hermetic science of Scurvimancy, an unpleasant practice involving the close analysis of the teeth and gums of sailors for purposes of prognostication. This hallowed and secretive art was once employed by the worthies of Europe to divine the fate of empires — and to obtain reliable lottery numbers.

When one day a moist and leaking package arrived, I assumed that it was my long-awaited book on Scurvo-divinatory techniques. I tore open the box, eager to examine my prize and begin what I hoped would be my most famous, well-respected, and profitable work to date. But, alas, this was not to be. Here was another tome entirely, if indeed it may even be called a book. To this day, I do not know how it came to be sent to me. All the enquiries I sent to the antiquarian booksellers I deal with have met with confusion, strong denials, or carefully worded threats from their lawyers.

The Goblin *Codex* exhibiting its distinctive and aromatic scrod-fish bookmark. **∨**

I can now say without hesitation that the *Codex* is the most important document in the history of Goblinology. Far more than a mere text, it is an invaluable artifact, a doorway into understanding the Goblin Realms. This book is clearly centuries old, marked by long years of both use and abuse. Frequently rebound to fit prevailing goblin fashions, the *Codex* shows evidence of having resembled a psalter, an enormous Chinese take-out menu, a mighty tome bound with brass bands and beef jerky, a trumpet, and now, that most beloved of goblin lunches: the scrod-fish and vellum sandwich.[1] Whatever it may look like on the outside, what resides between its covers is stranger still: pages covered with diagrams, and texts written in goblin scripts from every age of their long and bizarre history. Curious flattened objects are sewn or glued to its pages, and strange sounds and unpleasant odors issue from between its leaves.

It is for the goblins also a sort of yearbook and scrapbook containing clippings from mankind's writing *about them*. More important, it is the book in which the various goblin Guilds and Houses have always recorded their ongoing feuds and contests in and about the human world. Everything written or said about goblins in the human world is stolen or copied by the goblins into this, their mighty national chronicle; but these mortal additions surely merit further study, and we may return to this material in time. Indeed, I wonder if the study that Froud and I are currently undertaking may one day occupy its own place in the *Codex*. 'Twould be an honor indeed!

[1] *Absurd in its present form, it was certainly the* Codex's *strong resemblance to a grotty sandwich that allowed me to sail so easily with it through airport Customs.*

Dr. Berk examining the *Codex* in his usual scholarly fashion **>**

THE GOBLIN PHOTOGRAPHS

When Froud had finished fingering the goblin tome (without pausing to wipe his stained hands), he began to tell me about the strange photograph he had sent me. As he spoke, his eyes took on a wild look. He glanced furtively this way and that, as though he feared we were being watched. He called loudly (twice) for the steward to bring more wine, even though there were two full bottles yet unopened in front of us, and he does not employ a steward. He was muttering again, but I listened and began to unravel the tangled thread of his tale.

It had all begun when he had found a curious photographic apparatus in the basement of the Cottington Archive. I was, of course, appalled that he had taken valuable Archive property without filing the appropriate paperwork. Since my election to the Curatorship of that esteemed collection, I've become concerned about such matters, and I informed him that naturally I would be filing my own "Removal of Cottington Property by a Disturbed Outpatient" form upon my return to the office. He merely scowled at me before continuing his story.

The Goblin camera reputedly having belonged to the Cottington Estate. Pictured here with Mr. Froud's unfortunate modifications. **>**

The camera had belonged to the Cottington family and was perhaps one used by Euphemia Cottington to take her now famous faery photos. Brian admitted that his only intention was to borrow and "slightly alter" the camera, enabling it to capture luminous images of dairymaids in the low light of a barn. His own journal tells of his early experiments:

January 2nd, 4:00 pm

Dairymaids did not show up again. Set up camera, attaching light-gathering cone, crystal diometer, and those chiming bits from the mantel clock. Low light through window as usual. Half-eaten pickle sandwich left by the hearth. No mice today. Trouble with plates, but finally able to get a single shot off. Development in my special solution showed a shadowy image of something resembling a short figure, or a jaunty sausage in a hat, but too blurry and obscure to tell for sure. Will repeat tomorrow if nothing better to do.

Next Day, 3:48 pm

Have not seen or heard from a dairymaid in DAYS despite renewing my advertisement in the local farmers' journals. Believe rumors have spread and they are avoiding the house. One crab cake and two-thirds of a hard Flemish cheese left on hearth. Why does Toby never come to fetch his dinner? Set up camera as usual but welded on the spectral phosphor rings with impressive effect: delightsome mood lighting. Picture taken of a shadowy spot on the back wall. After development: WONDERS! Must call Berk and tell him to bring Codex. Also: Run more ads for dairymaids.

Brian handed me the photographs: there were eight in all. Here was madness! Though historically goblins have been known as elusive creatures—dancing rudely at the periphery of our vision, if seen at all—these were unquestionably photographs of them. What's more, I had seen one of these creatures before. Stammering and astounded, I had a hundred questions for Froud (who was by now quite engrossed in reading the local farmers' classified ads), but he calmly directed me to address my queries to the inhabitant of his downstairs toilet. Confused but intrigued, I followed Brian into the dimly lit W-C.

I was shocked at what I saw, at the extraordinary rudeness of it all, and at the fact that Brian's wife had expressly forbidden such things. I was sure it would lead to no good, for one should never insult company by trapping them in the bathroom, nor disobey one's wife, or so I'd been told repeatedly by mine. Still, I introduced myself to the creature with as much formality as one might offer the subject of one's study. He had been perched with great grace upon the lowered lid of the toilet and had risen quickly when we entered the room. His yellow eyes bore a surprising cleverness and perhaps something else, but the light was dim and I felt it was not polite to stare, even (perhaps especially) at a goblin.

He spoke little, communicating in the most ridiculous postures imaginable. Through sign and gesture he made it clear that his name was Gargle and that he was a very great and important goblin. He indicated that he was a Scribe of consequence, a Lord of Inks and Quills. At first I was disinclined to trust him, for his hands bore little evidence of his profession, but his behavior was most civilized and he very soon ceased making crude caricatures of us out of bathroom cleanser. Indeed, at our departure, he bowed low and even removed his hat.

In that moment we came to believe that he would prove a most reliable guide to the Goblin Realms, a place whose intricacies were difficult to fully appreciate, even with my impressive but, alas, imperfect translations of the *Codex*. Also, we quickly learned that Gargle makes the finest toasted cheese sandwiches either of us has ever tasted. Consequently, we employed him. Only my own inability to remember where I'd seen him before continued to give me pause.

I've returned many times to the pages of the *Codex*, hoping to find an image of Gargle that might rekindle my memory or tell me something more about him. I've leafed through its moldy pages, past the portraits of the Great Goblins of yore. He was nowhere to be found, and the index proved unhelpful when it could be located at all. I did clearly recall a familiar image near the chapter chronicling the roles of goblins during the Middle Ages, but turning to it, I found nothing but evidence of a torn-out page.[2]

and handsome too!

[2] *None of this surprised me terribly, for in the short time I have been working with the* Codex, *I've learned that its contents have a curious habit of shifting and changing quite unexpectedly. Three weeks ago, for example, I was in my study reading a fascinating account of the invention and history of the gammerstang: a subtle but effective goblin device responsible for the persistent dead-mouse smell afflicting many older houses. I had set the* Codex *aside for a few moments and upon returning to it, I found the pages I'd been reading gone: in their place was page upon page of an early 1970s Czechoslovakian phone book. Fortunately I had taken notes, for the* Codex's *gammerstang entry has never come back. Sadly, the same cannot be said for the dead-mouse smell in my study.*

REF. No. GA/0039e1Fe

NAME: Laantorn

A goblin to be feared in all his manifestations. Fire is his nature and his calling card. His work often begins very quietly but can end in disaster. His favorite trick is swiftly flying through a room and knocking over candles. Also causes appliances to smoke for no apparent reason (we have taken to calling him "Sparky," which he detests). Plugging five or more plugs into a single outlet by means of an adaptor immediately summons this goblin, who considers this a kind and heartfelt invitation to a mortal home.

TIME: 10.48pm;
Jupiter aligns with Mars.
LIGHT: Crepuscular.
CONDITIONS Bored.
BAIT: Old Moaner.*

* Pungent (large clothes peg recommended)

REF. GA/17eGgFUYONG

NAME: Floo

A creature of draughts who prides himself on bringing wind down the chimney to extinguish the evening's fire, or on shepherding a cold, wet air under the door. Though more annoying than dangerous in ancient buildings, he might cause real trouble in newer homes, where he could blow out the pilot light on the stove, filling the kitchen with gas. Chills, aches, and agues also frequently attend his visits.

TIME:	07.01am; Halibut Flopping.
LIGHT:	Glow-worm in Chianti bottle.
CONDITIONS	Runny nose. Goblin unsympathetic.
BAIT:	Stinking Bishop.

veree fyne fotograff

REF. No. GA/09628E

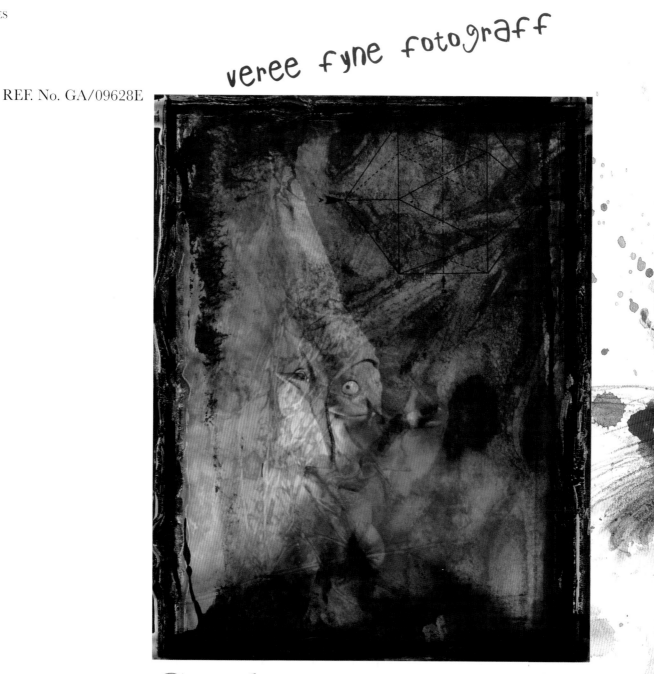

NAME: Gargle *the bootiful*

A goblin Scribe. His timely arrival was attended by much bowing and rude pointing of fingers, followed by Brian's locking him in the loo to await further study. Bright, unsettling eyes, very quick handed and much *gravitas* for such a small fellow.

TIME: 11.49pm;
Capricorn Rising.
LIGHT: Four Candles.
CONDITIONS Indigestion.
BAIT: Roquefort.

REF. GA/16630F

NAME: Catarrah

A very common goblin. His most recent visit was followed by every member of household developing immediate and ferocious cold symptoms. Bag seems to be the source of his accursed power. Perhaps filled with used handkerchiefs (or something wetter and worse), this cruel sack is used to swat his victims about the nose and face. Very rude, we call that.

TIME: 07.15am;
Gemini in opposition to Leo.
LIGHT: Chink of light under the study door.
CONDITIONS Grumpy.
BAIT: Camembert.*

* Piquant

REF. No. GA/Bg75-13f

NAME: Lumin

Once many ages ago, he was (he says) the goblin who blew out candles at inconvenient moments. He has cleverly adapted to the times and now causes untimely expiration of lightbulbs. He can also bend light and cause blinding flashes, usually just as you've gotten up the ladder to change the bulb. Though usually most troublesome, he harbors an ongoing feud with Laanthorn and will, if you're lucky, blow out a fallen candle before it can cause any real damage. (But in doing so he angers Floo, who considers it *his* job to extinguish everything.) A fine example of goblin pettiness and their fanatical overemphasis on individual – and occupational – rights.

TIME: 02.18am;
Fell asleep.

REF. GA/Uv1339k9

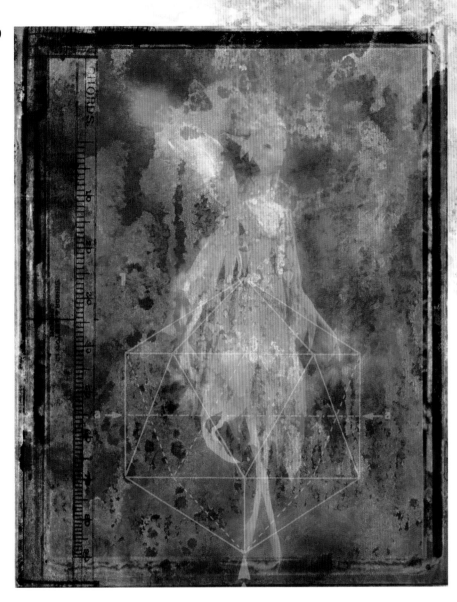

NAME: Bloewsabella

Often traveling with Floo, she is the goblin of ice and fierce cold. In her kinder moods, she contents herself with rapidly cooling off the meat before it reaches the dinner table and resetting the refrigerator to ice the fruits and vegetables. In the full flush of vengeance, she once froze our water pipes, causing them to burst and spray water onto the kitchen floor. She then turned the puddles of water to ice, resulting in several nasty falls, though the game of indoor hockey we played afterwards made all worthwhile.

TIME:	03.59pm; Uranus Conjuct
LIGHT:	No lights–fuses blown.
CONDITIONS	Damp Armpit.
BAIT:	Runny Robert.*

* Soft interior, handwashed rind.

REF. No. GA/7847IJ

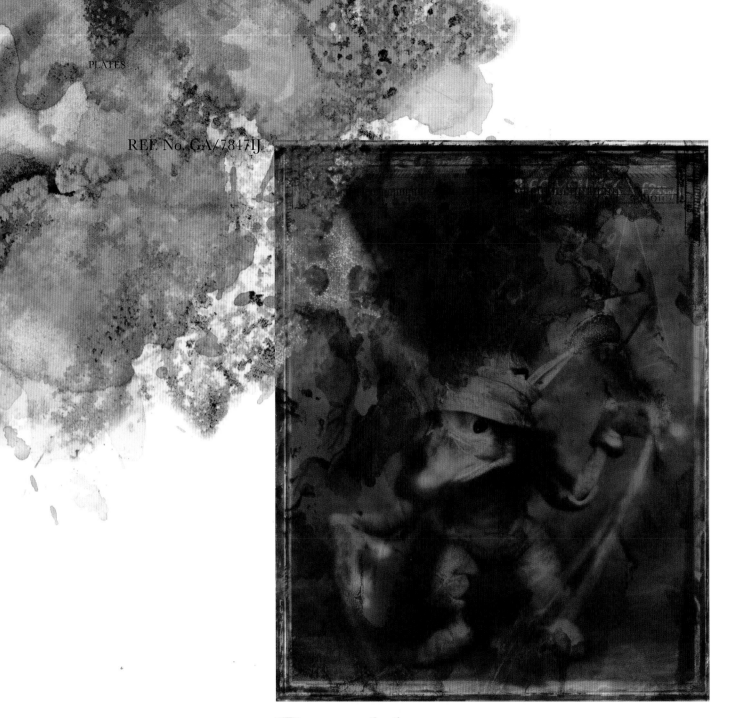

NAME: Damblynge

A sticky-fingered goblin thief and cutpurse. His usual, and extraordinarily annoying, method is to steal only one item from a pair: one earring, one sock, one glove. We have wasted DAYS in search of the mates. What he does with the pilfered halves of these broken pairs we cannot guess, but we hope he's getting a fair price for them.

TIME:	05.02am; Saturn trine Mars.
LIGHT:	Torch.
CONDITIONS	Frolicksome.
BAIT:	Sainte Nellis.

REF. GA/7265g57

NAME: Malecha

A notorious milk curdler. Though milk, cream, and butter are her favored media, she can put anything "off." She once passed her cruel but delicate hand over the freezer and even the ice cubes were befouled.

TIME: 23.23pm;
Sagittarius Retograde.
LIGHT: Bonfire of old unpaid electricity bills.
CONDITIONS Insolvent.
BAIT: Festering Fenmould.*

* Should be buried under concrete immediately

17

Part I GOBLINS IN THEIR WORLD

An intimate tour of the Goblin Realms, in which several semi-puissant polities are revealed, certain secret and ludicrous practices are for the first time described in needless detail, and several goblin worthies are introduced as politely as possible.

Bestowed of many rich feasting halls, high towers, and resplendent bowers, we may envision the world of Faery as a kind of palace. If we adopt this apt metaphor, we may then more accurately perceive the relative nature of the Goblin Realms as a kind of damp sub-basement.

But how do they get here, traveling so far from their nasty little world? As it turns out, the Goblin Realm is not so very far away at all. Their world intersects ours constantly: the two flow together at a thousand places, at every instant, like two streams crossing each other many times before finally converging into a stinking mire or fen. Where do those intersections occur? How can you know if you are near one?

In every mortal home or building, there is a door to the Goblin Realm. These thresholds are are always found in the Darkest Corner, where light never falls: under the stairs, behind the refrigerator, on the far side of the curio cabinet (just under the statue of Elvis made from real sea-shells that your Aunt brought you from Boca). Yes, there! Do you recall the stiletto-heeled black leather pump you bought because it was on sale but then you never wore because it didn't fit you even on the day you bought it? Check the toe.

The mortal world has suffered an age-old, and now verifiable, relationship with goblins; they come here often for "recreation" and can't help leaving evidence of their little visits. Slime trails, oily puddles, foul odors, and a catalogue of unlucky events are all evidence that they are certainly the most common, unpleasant, rude, crass, bold (and now and then the cleverest) denizens of Faery ever to cast havoc upon our world. Goblins have notoriously obnoxious senses of humor, and for thousands of years humans have been the hapless victims of their appalling tricks and japes.

We have discovered that goblins are the anonymous (until now), untidy authors of most of our everyday accidents and annoyances, troubles and travails, calamities and catastrophes. They rejoice in causing chaos, spreading stains and stinks, and causing mischief wherever and whenever they arrive. They are tenacious troublemakers, mischief merchants, ribald rascals, scheming slinkers, Lords and

Ladies of Misrule, dangerous dandies, and all-around rogues. Wretched they are and yet, we must admit, also strangely intriguing.

For years Brian's house has played host to frequent small-scale goblin visits, so we were able to set to work immediately, filling boxes and bags with clues. From the moment of my arrival at Brian's home, we were scraping evidence from the floors and ceilings and soon had amassed hundreds of jars, vials, buckets, and plastic bins filled with "foul lovelies" (as Brian insists on calling them), to be sorted and catalogued later. As an increasing number of goblins visit the house, Brian is constantly sketching (for photography is a slow and cumbersome process, and the goblins won't always stand still long enough for him to snap their picture), in an attempt to catch as many details as possible before they vanish. The goblins seem not to mind being seen. This is curious. Are they just getting sloppy, or are they becoming bolder and more arrogant? And if so, why?

The assistance of Gargle the Scribe has proven invaluable. However, his employment as our translator and guide has not been easy. In fact, he was at first totally unwilling to actually speak to us. By means of a bribe (seven cans of miniature cocktail hot dogs), we finally enticed him to begin conversing with us in English. In exchange for his assistance, we agreed that he could write his own "contribution" to this section. Herewith:

Gargle's literary contribution in his own distinctive manner, on what is believed to be finest Leiderdammer. >

Help.

I trapped in downstairs water closet. Mr. Froud very bad man. "Dokter" Berk no better, though much larger than short short paint man. Am good goblin. Do no harm. Make pretty pictures. Write loverly words. Please. Come to Froud ground floor poop-cupboard and unlock door. Will give you many socks and a small dog with cheese on him. —

GARGLE

grete drawerring

∧ Gargle's map of the Realms drawn with typical goblin prescision

wot they mean?

It is written in that annoying, childlike patois that goblins insist upon affecting when trafficking in our world, and, generally speaking, it is a shameless ruse. Many goblins, particularly the Scribes, are perfectly fluent in our tongue and nearly all of them can compose superb limericks in the king's English at a moment's notice. Their relative eloquence, or lack thereof, is often a matter of mood, personal inclination, or whim.

Informing him that we were aware of his pretense, he sighed, recited an embarrassing limerick on the theme of belly-button lint and the immortality of the soul, and continued in a lovely lilting rasp common to many of the better goblin upper classes. You see our problem: even at his most helpful, we must always read between the lines and interpret his curious, and often offensive, metaphors and obscure quips.

From Gargle's endless ramblings, rough drawings, bawdy songs, and incessant complaints — as well as our own translations from the *Codex* — we are able for the first time to pull back the moldy curtain, revealing the great Goblin Realms in all their putrid nobility. Their reeking and slippery Cabinets of Curiosity and Design are now known to us. We have learned of their Feats of Disturbance and Commotion, gathered invaluable data regarding their Devices of Mayhem and Diversion, and discovered rare details of goblin holidays and calendar customs. With no thought of our own safety, we have amassed the following vital and never-before-heard information regarding Goblins and their traditional practices. We believe that only by thoroughly familiarizing you, Gentle Reader, with their culture, habits, habitats, and practices, can we hope to protect you from their frequent incursions into our world. Read on.

BASIC STRUCTURE AND POLITICS

A feudal society, the goblin world is filled with innumerable hamlets, villages, hidey-holes, caverns, ramshackle shantytowns, garish halls, noisy mills, and not-quite-delightful subterranean cafés. Larger political divisions exist, however. The goblin world is split down the middle into two main "noble" Houses. Shifting alliances, deceits, and intrigues plague goblin history but delight its Scribes and Bards. In his official capacity as goblin Scribe and Chronicler, Gargle spoke of an ancient Crud-feud that exists between the Houses. Each seeks dominion over the other; the balance of power constantly shifts in response to ongoing contests played in (and at the expense of) the mortal world. Goblins thrive on hierarchy: each goblin, from king to lowly footpad, strives to know his place so he can lord it over some lesser creature. Their

pettiness and concern over posterity is infamous throughout Faery. Except when forming Guilds (who are united by a single absurd "mission"), most goblin alliances do not generally last very long, instantly dissolving if anyone is slighted, insulted, or feels that his or her area of expertise is being usurped.

Fame, honor, and position in goblin society are won, maintained, and insured through petty thievery and causing mayhem in the mortal world. Objects stolen from us are the goblin's most prized possessions. Such objects are seen as the spoils of battle and are often revered for some perceived arcane power. The more common and worthless the object in mortal world, the more holy, venerated, and valuable it is in the Goblin Realm.

The ancient flatulent matriarch, The Royal Lady Empyreuma Frouzy >

nonsense this is sardine sallie she olde girrlfrend

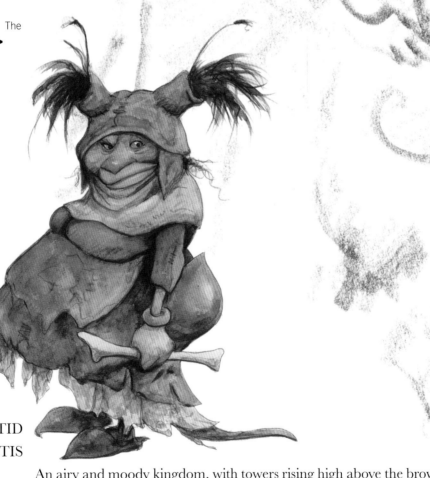

THE NOBLE AND FETID KINGDOM OF MEPHISTIS

An airy and moody kingdom, with towers rising high above the brown, tattered clouds. The annals of Mephistis insist that it is *the* most ancient of the goblin Kingdoms (though the annals of Malkin assert the same thing). Aeries are its most popular habitation, for many of its denizens fly, ride winged creatures, or use crude flying devices that enable goblins to drop foul "gift" baskets upon their victims. Wings and winged devices are also very useful for fanning oneself during the long hot months of Sonisot (which are scorching in this part of the goblin world), but goblins seldom remember that they have them, even when they are using them.

Mucor **V**

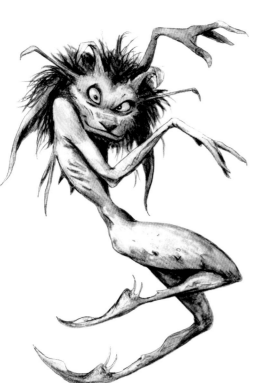

Here may be found the infamous and foul Windy Workshops, as well as Canniken's Floating Academy, where noises and stinks are crafted. The entire region is an olfactory abomination: cracks in the ground emit the most unpleasant vapors imaginable, while enormous braziers on tripods burn the wretched goblin cracken-coal (which is mined exclusively in this Kingdom), whose smoke has the ability to bring even a noseless man to his knees. None of this seems to distress the Mephistean goblins, who proudly refer to their realm as the "Kreptid-pluut."[3]

This Kingdom is ruled by an ancient flatulent matriarch, The Royal Lady Empyreuma Frouzy, from her luxurious hammock, hung between its highest flagpoles. Brittle, dusty, and noisome, Lady Empyreuma is attended by her Ladies-in-Wailing — a gorgeous crew of cold-skinned goblin bachelorettes, all of whom have tiny mouths that they can open to an enormous size when emitting their piercing cries of imperial adoration or crankiness. Ironically, Lady Empyreuma cannot herself fly, and must be carried by her ladies, which is no doubt the source of their renowned bad moods.

It is extremely rare that the Mephistean royals would ever venture from their hammocks, but several days ago, we caught a brief glimpse of Lady Empyreuma making a mysterious progress through the laundry room, where she stole three cans of lavender air freshener and then vanished in a cloud of yellow sulfur. Such a visit must bode something; but again, Gargle absolutely refuses to comment.

THE GREAT AND PUTRESCENT KINGDOM OF MALKIN

Deep within the fens and marshes of the goblin world bobs the half-sunken Kingdom of Malkin, ruled by twin adolescents, Their Highnesses, Mucor and Rubigo. Although known for their cleverness, these young goblin lords are extremely immature and are entirely driven by immediate desires. They have the shortest attention spans of any goblins, which is really saying something. Childish in temperament and appearance, they both charm and annoy their numerous admirers and caretakers by their constant demands accompanied by a nasal "Now, or we step on your toes!" They can change their minds faster than you can say "slap the nanny," and their ability to speak simultaneously in bizarre sing-song voices is both uncanny and totally annoying. Any shiny thing delights them, as do frequent naps, and finger-painting.[4]

This Realm is primarily inhabited by the goblins responsible for stains, broken housewares, petty thievery, toast-related tragedies, and most tricks involving physical manifestations of the goblin sense of humor. Stain projection and propulsion are the Malkinites' special pleasure. They have amassed great hordes of botanical knowledge

[3] *A curious word which means, depending on inflection, either "my-flower-perfume-happy-happy-place," or "onion-skin-covered diaper-pail of my heart."*

[4] *This is not, as you might think, the common art of painting with one's fingers, but the far rarer painting of fingers, which they model from the evocative gestures made by their personal attendants (whom they frequently offend), and varnish with their favorite colors: black, blackish, and dun-mutt.*

Rubigo >

and are eager scientists who use, develop, create, and breed plants, pigments, fluids, jams, and jelly-like substances to leave as their "calling cards" in the mortal world.

Malkinites take particular joy in the fine art of painting. Using brushes fashioned from scrofulous possum hair, Malkinite painters use phlegmatic inks and varnishes to cover the mortal world in mucilaginous murals, horrific graffiti, and insulting splotches. Because of their natural artistic abilities, many Malkinites become Scribes for the Goblin Chronicler's College, but are required, upon matriculation, to renounce any and all former allegiances.

GOBLIN SCRIBES
AND BARDS

Residing in the politically independent Collegiate Crannog, Scribes and Bards are the real power brokers of the goblin world. Technically independent of the two Kingdoms — but deftly manipulating them — they are the former keepers of the recently discovered *Codex Goblinensis*, though how or why they let their national treasure pass from their hands remains unknown.

Goblins are preoccupied with their own posterity,[5] so Scribes hold positions of honor and look the part. Their trailing scholars' gowns, embroidered with calligraphed strips of vellum stolen from mortal books, and their absurd "academic" caps are, by royal decree, the longest and most ornate outfits to be found in the extensive catalogues of goblin ritual couture. High-ranking Scribes are followed about by scurrying packs of under-Scribes burdened with scrolls, tomes, rune-staves, and vials of soothing eyedrops.

Goblins from the two great Houses attempt to win favor with the Scribes by performing Feats of Disturbance and Commotion, trying desperately to ensure that their names will

[5] *And indeed their own posteriors.*

be honored in the roll-call of the Goblin Greats. In the Goblin Realms, self-promotion and self-aggrandizement are obsessive national art forms (no doubt the reason for their delight and relatively high comfort level in our own world of late).

Goblin Scribes and Bards are not objective recorders or reporters. They are professional *inciters* (the goblin version of CNN) using their knowledge of ancient goblin history to inspire squabbles, challenges, competitions and feuds among the two Great Houses and their retainers. They have representatives at both Courts and are unashamed bribe takers, ensuring that the praises of any goblins willing to pay are duly exaggerated, thereby obtaining a more auspicious placement in the *Codex*.

goblins!!!
at last

GOBLIN GUILDS

Hallowed, ancient, competitive, corrupt beyond reckoning, and remarkably efficient and cohesive for goblin-run organizations, the guilds have existed since the Slippery Days of the first goblin dynasties. Their origins are shrouded in mystery, but we do know that they began as family-run goblin societies that strong-armed less organized faery folk into purchasing their absurd handicrafts and goods. Recorded in the *Codex*, the earliest guild charter was granted for the production of and sales rights for septic cheese.[6] Other early patents were awarded for snake smuggling, rotten fruit distribution, switching the salt and sugar bowls at mortal feasts, and bad hams.

Many streets in the two Kingdoms are named for the guilds that first settled them. Within each Kingdom are numerous goblin guilds, each specializing in a particular form of mayhem and mongering. "Slippery Lip Way," "Howler's Street," "Curdler's Alley," "Blighter's Road," and "Dogges' Alley," home of the Fell and Ferocious Dog Riders, all bear proud testimonial to the early work of the guild masters and their eager crews.

Guilds have always existed to protect their own interests, and woe to any creature, human or otherwise, that gets in their way. Even amongst themselves, members of the guilds are extremely competitive, and their annals and official histories are filled with accounts of *Gobfell*, or Guild Wars. Such battles are waged for a variety of reasons: territorial disputes; perceived ownership rights to prized mortal items such as cat food, lemon reamers, or the cardboard tubes at the center of toilet paper rolls; and disputed monopolies on used toothbrushes. Often, fights break out between guilds for some small breach of goblin etiquette, such as forgetting to exchange the traditional box of soiled mortal socks during the month of Grotsuntide. On rare occasions, two or more guilds will band together to pull off large-scale jobs, but this is the exception rather than the rule, and such alliances never last longer than it takes to complete the task at hand.

Disputes form the earliest history of the guilds. Indeed, the first goblin monarchs were completely disreputable in establishing the guilds, often selling the same patent to several different families.[7] For the most part, goblins, especially nobles and Scribes, are fond of

[6] *A renowned goblin delicacy*

[7] *Though grossly unfair, this is typical of the "goblin way," and when, in the year 3452 of the Great Reckoning, the Fabulous Counselor Crekeld the True (the only goblin ever to use the word "true" in his name) set about to reform this system, he was promptly stripped of his office as well as his flame-red and highly unorthodox satin under-tabard, and thrown into the river.*

this sanctioned lack of honest protocol because it leads to terrible misunderstandings, frantic doubts, scurrilous lies, and petty in-fighting—in other words, all the chief delights of the goblin world.

To distinguish one guild member from another, each carries a device related to his profession on a stick (a manikin in the shape of a mortal pet, a rotten pear, a piece of dirty toast, a toilet brush, etc.), and members are required to wear livery and tabards with the device of their guild stitched, glued, and/or painted on them. Of course, goblins' memories are shorter than their little toes, and goblins hardly ever wear their tabards or remember to carry their sticks, so much confusion attends the meeting of two or more guild members. The traditional intra-guild greeting — "Yes? You're with? I thought…no? Then I'm with? When?! Oh! Of course! I'm, wait. Okay. Okay. Okay. I've got it! Wait. You are? What?! Well, thanks for the cheese." — is commonly heard at goblin functions.

Of course, such confusion and petty squabbling have much degraded the guilds over the long years since their founding. Guild Members spend almost as much time fighting amongst themselves as they do in fulfilling their charters. Yet the oldest Dimber-Dambers (the title of all guild chiefs) insist that the guilds shall assume the heights of greatness again, and they mumble a sad and decrepit prophecy that promises, "a riche world awaits only two fooles to open the door." As to how this old yarn might be accurately interpreted or achieved, Gargle again refuses to elaborate.

ummmMMm!

We have asked to him to give us the names of all the goblin guilds. He refuses. We've asked him for the names of only the most important ones. This he also declines to do. How about the most interesting ones? "Thirty-six" was his answer. When we asked to be told about those, "Nope," was his reply. Well, might he just tell us which ones were in the house last night? *That* he condescendingly agreed to reveal.

We learned that no less than six different guilds had visited the Froud house the previous evening, leaving a terrific mess that someone was going to have to clean up. An early phone call confirmed that two of these guilds had also visited my home in the States very recently; my wife was still sweeping out the mouse droppings.

Here follows Gargle's revelations concerning six notorious goblin guilds:

THE VERMIN'S GUILD, OR BROTHERHOOD OF MERRY MOUSE DANCERS

Members of this elite guild lead all manner of small vermin into mortal homes by singing their guild song, which starts with the words "Little Friends, Welcome and Scurry Ye Here," and ends with "Soon big-folks will be running, so a new home for you!" The special skill and art of this guild resides in placement and timing. One or two little mousies found behind the flour sack is happenstance, commonplace. But 943 mice, carefully arranged under your bed sheets to look like your spouse — now *that's* the kind of feat attributed to senior members of this guild.

ARSEY VARSEY — A TUMBLING GUILD

Little is known of this guild's membership, or rituals. They are often to be found rolling, leaping, and somersaulting through mortal living rooms where they knock over plants, upset chairs, bring down shelving, and generally make a mess of things before landing gracefully on their feet, to the delight of your cat who is saved the trouble of doing it herself.

THE NATTY LADS AND LASSES GUILD

Also called "The Bilking Bubs," this is a guild of cheats and thieves. There are, of course, numerous thieving guilds, for this is the most common activity engaged in by goblins, and even members of non-thieving guilds are expected to bring a little "shiny" home for the missus. The Bilking Bubs are headed by their Rig Master. The holder of this ceremonial position changes almost daily, for it is immediately rebestowed upon the next goblin to perform the best and most daring bit of thievery on a given day (called the "Thick Tricke"). The previous Rig Master is then publicly stripped of all honors (a kind of honor in itself) upon the Portico of Flogs and Slaps, located just outside their guildhall — more a grimy-shingled hut than a hall, if truth be told. Their tabards bear the heraldic emblem of two sticky fingers poised to pinch a trinket from a platter of cheap costume jewelry.

BLOTTY BRUSH AND NOINTERS GUILD

Colloquially called "The Knights of the Chamber Pots," they always carry reeking paints and queasy inks with them to render offensive any available wall in a mortal's home. These they quickly cover with stains and smirches, snotty and blowsy portraits, slimy designs and crusty crayon innuendos. Their favorite canvasses are the walls of children's rooms. Sadly, this usually results in some innocent human child catching the blame for the work of this wretched goblin crew. They are quick to steal "art supplies" from their victim's homes: no available substance is too foul for their use, and many weighty diapers have been plundered to provide pigment for their more inspired murals.

FELL AND FEROCIOUS GUILD OF DASTARDLY DOG RIDERS

Only guild members use this frightening title. Other goblins refer to them simply as the "Pooch Pinchers," or the "Cur Collarers." The heraldry upon their tabards and riding-flags shows a Chihuahua Rampant upon a field of stained shag carpeting. They are frequently found in our world, where they fulfill their ancient charter by riding dogs around in circles, encouraging them to chase cars and their own tails — absurd pastimes that no self-respecting dog would ever engage in on his own accord. Their high-pitched battle cry of "Puppies, Away!" will send any dog into a fearful fit of howling.

AUGUR'S GUILD

Also called "The Caravan of Auspicious, All-Seeing Nosticators," they practice one of the most popular pastimes in the Goblin Realms: the fine art of soothsaying. The memories of its members are renowned, for it is believed that each Augur has thoroughly memorized all forms of prognostication. (However, it is widely suspected that most of the fortunes prophesized by guild members are made up on the spot.)

Of the thousands of different divinatory methods recorded in the *Codex* and practiced by the Augur's Guild, here are a few of the most frequently requested:

Scullerymancy: flinging all the pots and pans to the floor and studying their relative positions.

Cromniomancy: a method of divination by onions in which the teardrop splatter patterns made by crying humans are carefully analyzed.

Axinomancy: soothsaying by hatchet throw.

Toastimancy: the art of prophecying by reading pieces of bread: fates are decided based upon whether they fall butter-side up or butter-side down. Should a piece of toast ever land upright on its edge, it heralds the end of the goblin world and thus the Augur's Guild itself. Such apocalyptic toast events have happened hundreds of times, but senior guild members have always been on hand to quickly knock over the toast before anyone else saw it. This kind of augury frequently follows or begins a game of Butter Tiles.

Myromancy: soothsaying by studying the manner and method of an ant's lunchtime activities.

Omphalomancy: divining by belly button examination and exploration. (It is not known whether this is accomplished by a goblins using his own belly button, his client's, or some unlucky human's.)

Uromancy: divination by reading the bubbles formed from urinating in a pot, a bowl of porridge, or any other place likely to annoy humans.[8]

[8] *A curious note: When consulting the* Codex *about the history of this guild, we found two entries that appear to have been hastily and recently scrawled into the section on divinatory pastimes:* Berkomancy: *leaving several fillets of smoked fish out on the kitchen counter overnight and counting the number found remaining the following morning to obtain a prophecy. (Since there are NEVER any left for breakfast, a bad omen is generally guaranteed.)* Froudomancy: *watching artists stumble towards the bathroom in the night and counting the number of times they run into a wall. (Both a divination and a highly popular form of goblin gambling.) It seems obvious from the above that our studies are contaminating the goblin world. Important issues of academic objectivity and protocol should be attended to but time is short and, more important, THEY STARTED IT!*

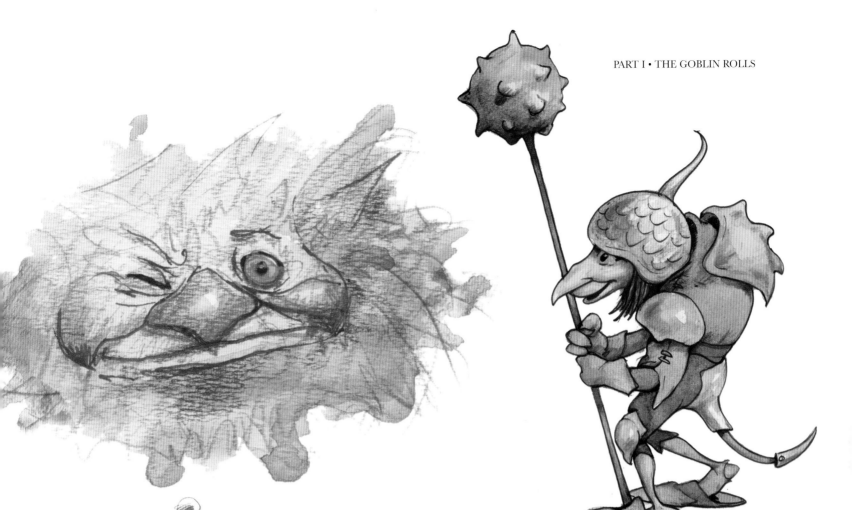

THE GOBLIN ROLLS

In which several prominent portraits from the Codex Goblinensis *are enlarged and presented.*

⁹ *Note: The goblin texts are written in an archaic form of goblin script which we have loosely deciphered. To these translations we have added lab notes, our invaluable interpretations of goblin habits, and indications of their possible presence in your home. All this must be considered speculative at best. Only Gargle's hints and our own life's work, dedicated to the study of cryptography, hieroglyphics, and home-heating repair have allowed us to make any sense at all of this goblin "Hall of Fame."*

From our first exploration of its pages, we knew that the *Codex* was also a kind of goblin phone directory, with all the most interesting goblins having portraits that record and advertise their particular specialties in the various arts of mortal annoyance. These portraits might be used by the heads of goblin guilds to assemble new and more effective crews, or they may merely be arrogant advertisements through which goblins establish their own reputations for purposes of posterity. It is likely that goblin Scribes and Nointers (painters) are bribed to make finer illuminations for those who can afford to pay. Therefore, the quality of one's individual portrait in the *Codex* is in itself a way of establishing a higher or lower place in the complex goblin hierarchy.

Making occasional corrections over our shoulders as we pored over the *Codex*, Gargle pointed out some of the better-known goblins that frequently visit our mortal sphere for purposes of mayhem-making.⁹

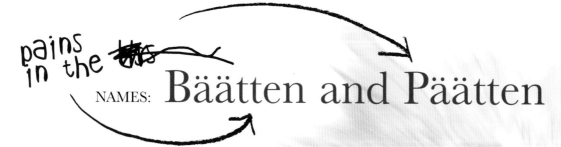

pains in the ~~this~~

NAMES: # Bäätten and Päätten

TITLE/TYPE: *Brakium Soritis Feres*, or, Bullying Back Breakers

KNOWN HISTORY AND/OR HABITS: Bääten and Pääten are brothers and co-founders of the very successful Guild of Aches and Agues. Their chief talent is the cowardly and ignoble art of bastinado, or "Crackers" (as they call it), the delivery of vicious full-body spankings with specially carved batons and forged maces. Cruel in both appearance and application, these weapons are collectively known as the "dancing tantrums." Despite the fact that they are absolutely essential to the effective dispensation of their charter, the goblins often forget to bring these sacred implements when they visit the mortal world, and shoes, belts, or rubber-coated spatulas ("bouncing trouncers") are used as substitutes. The diabolical behavior of these goblins is always visited upon mortals in the early hours before dawn so that on waking, their victims suffer from a catalogue of mysterious aches and pains.

INDICATIONS OF PRESENCE: All manner of sore joints and muscle pain when rising from bed in the morning. The remains of a broken spatula may also be found beneath the bed. Many perfectly good mortal mattresses have been needlessly thrown away on account of these fellows.

EVIDENCE OF INFESTATION: If you wake up more than three mornings in a row to find two vaguely goblin-shaped shadows perched atop your buttocks and lower back delivering the spankings of a lifetime, assume the worst. Strangely, these goblins will never oppress anyone who is taking a nap during the daylight hours, likely due to the sacred nature of napping in the goblin world, and its important place in the goblin ritual calendar as a daily, hallowed, do-not-disturb event.

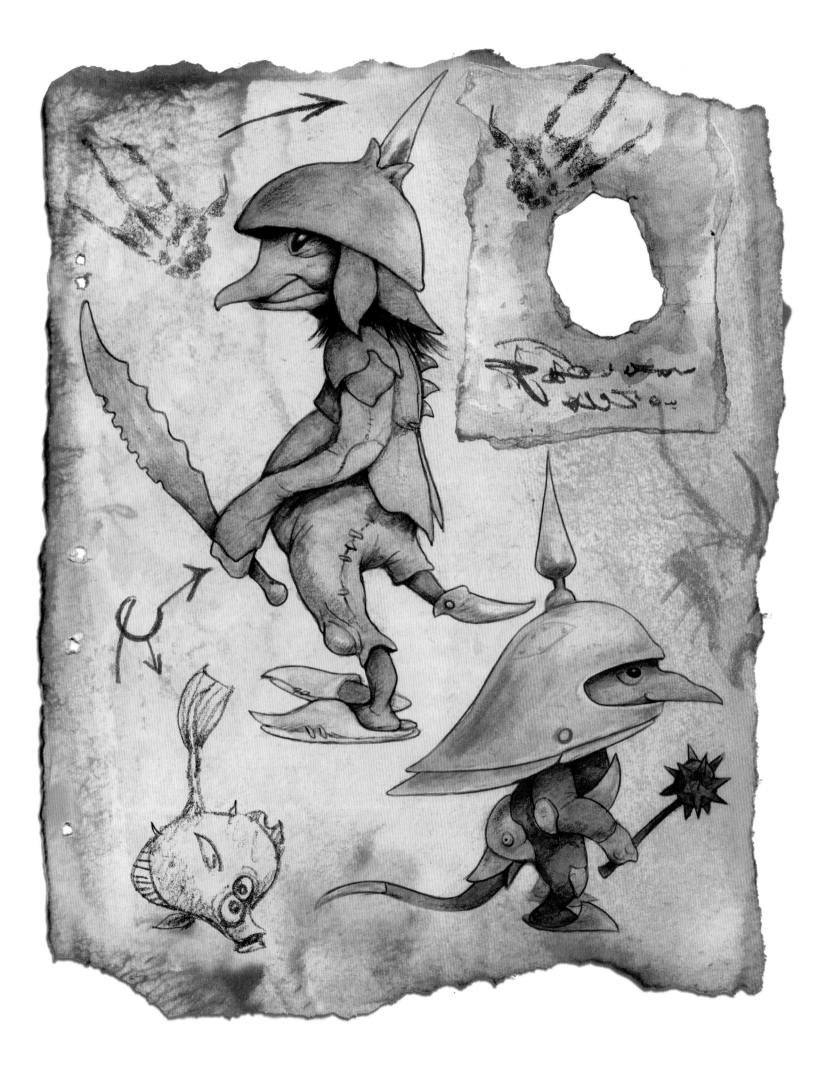

NAMES: # Shüüs

TITLE/TYPE: *Pedes Vestigium Waltzigrandum*

KNOWN HISTORY
AND/OR HABITS:
Sometimes called goblin footpads or lowly thieves, these honorifics refer not to status, but to the actual height and the relative lowness of the spoils these goblins collect: mortal footwear. They hate any kind of foot covering (which they call "blinders"), and they are especially fearful of socks, considering them a kind of cruel torture device.

These are the finest dancers in the Goblin Realms, for there is not a single "left-foot" among them. They are tireLEss, especially when intoxicated by any hint of a lemony-fresh odor. When not dancing the night away on the clean kitchen floor of mortals, Shüüs are possessed of both excellent memORies *and* a strong wORk ethic (qualities *so* rare among goblins). They despise any kind of forgetfulness whatsoever; should they find a mortal in a state of hesitancy, confusion, or laziness, they will immediately try to help him by dEliveRing a swift ferocious blOw to the posterior, in the hopes of either jogging failing memory or reinspiring an appreciation for drudgery.

INDICATIONS OF PRESENCE: Muddy tracks coveRIng the newly-cleaned kitchen floor.

EVIDENCE OF INFESTATION: Wild music below stairs at night, followed by a spate of footwear thefts. Also, the smell of burning socks.

no body here

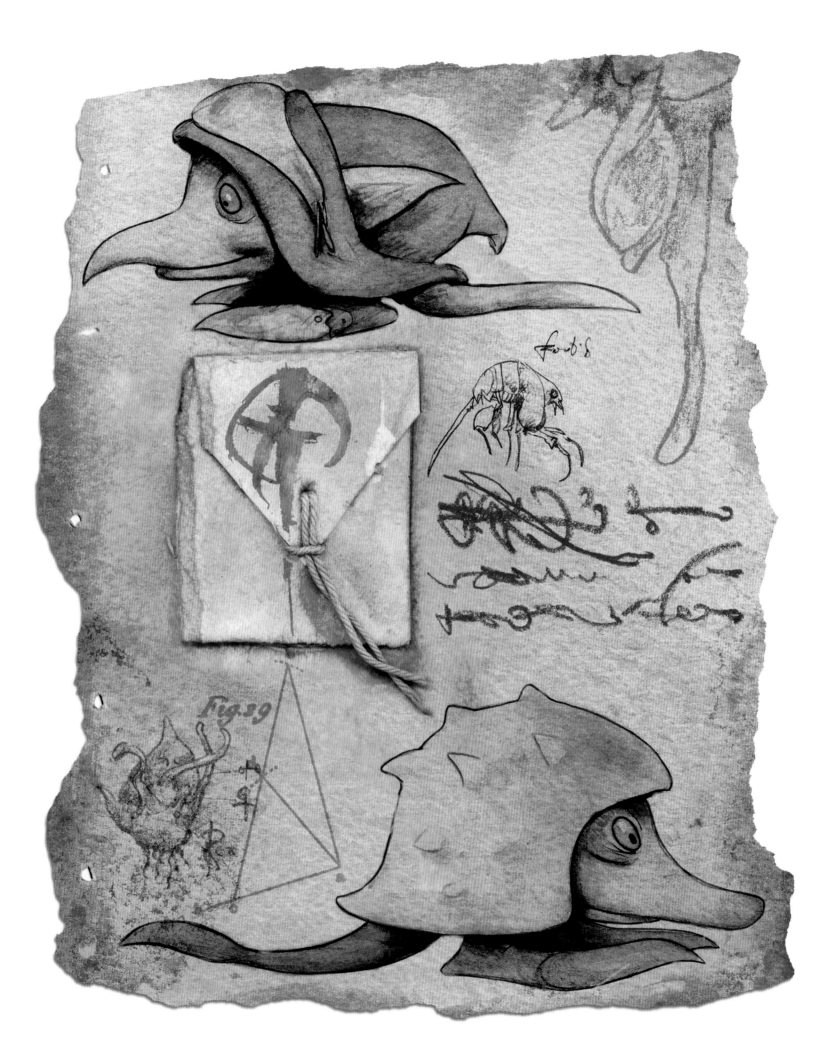

NAMES: # Floo and Cattarh

TITLE/TYPE: *Nasaleum Malleus Palus Floridiae*

KNOWN HISTORY AND/OR HABITS: Small and deceptively friendly in appearance, these two fellows, Mucal Lords of some standing in the Goblin Realms, are also called "The Runny Boys." They cause extreme discomfort in our world by spreading airborne illnesses. Floo is more active during the winter months when, riding upon the chill wind that is his calling card, he is the herald of all manner of fevers and bodily aches. Cattarh is more common, but beware! To call him "common" invokes his terrible wrath, and transforms what might have been a short visit into an awful extended stay affecting the whole family. He prefers to be called "Cattarh the Brazen and Bold, Lord of Nasal Flushing, Handkerchief Fouler, Head Stuffer Extraordinaire." (Well, a goblin can dream, can't he?) Cattarh's terrible weapon is feared throughout the Realms of Faery, for it is filled with disgusting mortal tissues, which he gathers in our world and then soaks in swamp water. The smallest tap about the head and shoulders with this foul hamper is enough to keep a full-grown mortal moaning in his bed for several days. It is said that to banish these pesky goblins, you must feed one of them, and starve the other, but no one can remember which is which. A surer cure may be found in the smell of chicken soup, which will (it is whispered by the wise) keep these terrible boys at bay.

INDICATIONS OF PRESENCE: Chills, draughts, coughing, sneezing, the sound of wings and tiny feet scurrying, heard near the head of the bed or about the medicine cabinet.

EVIDENCE OF INFESTATION: All of the above; also, being repeatedly hit in the face with a runny sack that smells like the Florida interior.

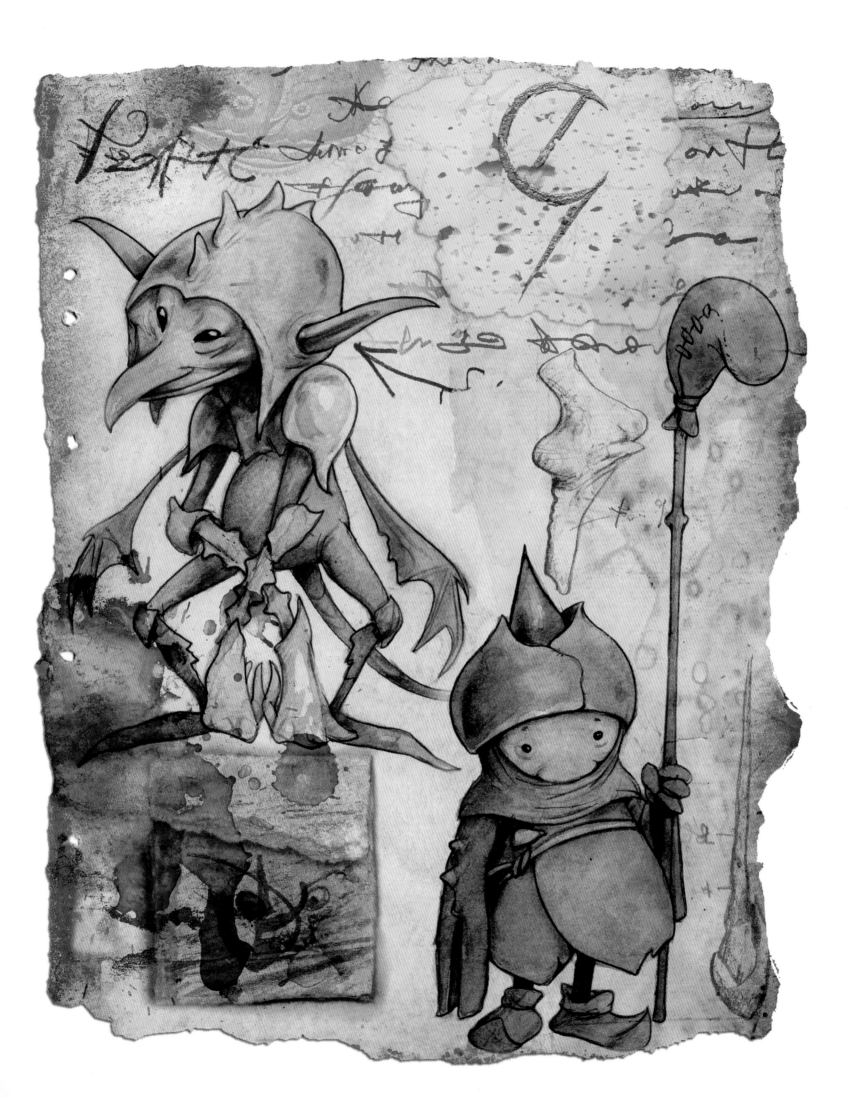

NAMES: Jylde

TITLE/TYPE: *Coquus Secretum Foetor*

KNOWN HISTORY AND/OR HABITS: Responsible for many mysterious odors found in mortal homes, Jylde is an accomplished goblin chef. Much sought after in the Kingdom of Mephistis, he has astounded his fellows with his highly creative, and occasionally hazardous, mortal-world-infused interpretations of traditional goblin cuisine. Favorite dishes include Roasted Medallions of Moist Hand-Wipe a l'Orangy-Detergent au jus and Found-Cheese Sprinkles; Hot Kitty Litter Parfait Crowned with Moldy Margarine and Festive Fifteenth-Century Parchment Confetti; and Meat with Meat Sauce and No Questions. Though he prefers his own well-equipped laboratory, he will occasionally use a mortal kitchen when he has to prepare something special. Fear not! Though he never cleans up after himself, he will always leave behind a little something tasty for you to try. However, ever since he lost a colleague in a freak defrosting accident, his mistrust of mortal refrigerators has been legendary. He will therefore leave your carefully prepared snack (such as Sweet, Sour, and Shiny Chicken-Foot Salad) behind the sofa, where, in the fullness of time, it will announce its pungent presence to you.

INDICATIONS OF PRESENCE: Fascinating and odorous hors d'oeuvres (made of cornflakes, dish soap, shoe polish, and a variety of past-their-expiration-date canned meats) are found in the coat closet just as your first dinner guests arrive.

EVIDENCE OF INFESTATION: Overnight appearance of a nightmarish buffet of foul goblin delicacies that even the dog won't touch.

Do try the canAPÉS, though; fragrant and so lovely! The bad clam juice really adds something.

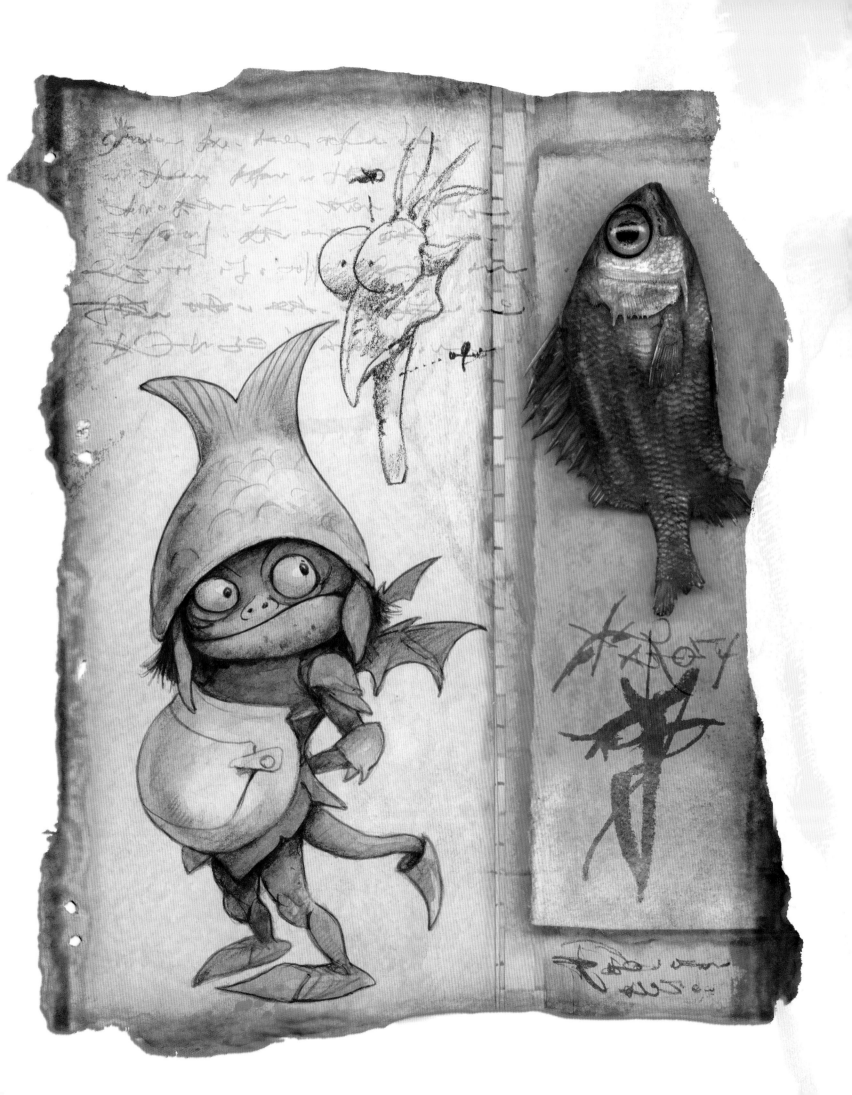

NAMES: Dinbole the Whittler

TITLE/TYPE: *Demens Caelator*

KNOWN HISTORY AND/OR HABITS: Once the stately Keeper of the *Two* Pearls of Rueful Pastimes, he is now the sad and dejected Keeper of the *One* Pearl of Rueful Pastimes, a real step down for him in the goblin hierarchy. The Two Pearls granted good luck and bestowed an uncanny ability to find the best deals on airline tickets. When rubbed together, they also secreted a very sexy-smelling after-shave lotion. One pearl separated from its mate is said to be cursed (though it still secretes a not-quite-so-sexy-smelling after-shave lotion). Eager to regain both his formal illustrious position and his sexiness, Dinbole searches night and day for the lost pearl. Sure that he left it somewhere in the mortal world, he leaves no stone or bowl of cereal unturned. Recently it was suggested to Dinbole that the pearl has been hidden from him within the wooden leg of a piece of dining room furniture. Precisely where he heard this remains a mystery, but he now spends every evening whittling away at the legs of chairs, china cabinets, and fine mahogany tables in the hopes of finding his treasure. By lucky chance, he is also the Keeper of the Great Goblin Scraping Scalpel, which has come in very handy in the frantic execution of his search. Unfortunately, Dimbole is also terribly nearsighted and refuses to wear his glasses. Because of his ferocious and half-blind wielding of the Scalpel, many mortal legs have received nasty nicks and thousands of women's stockings have been needlessly ruined.

INDICATIONS OF PRESENCE: Gouges and scratches in wooden table and chair legs. Subtle sawing sound heard at night, and the smell of fresh pine rising from small piles of sawdust found around the legs of the settee.

EVIDENCE OF INFESTATION: Your own legs covered with mysterious nicks and cuts, your pantyhose shredded, and the cat's legs shaved. Various items of household furniture may also be found resting, legless, on the floor.

NOT sharp

Gargles ~~stealing~~ Shopping liste
3 ½ × holed socks
1 × eel elbow
4 × candles
3 × copies of ~~The Runes~~ of Elfland Scurrilious
1 × small angry monkey
✓ Berks Brain
Fraud's brakenfrock

NAMES: **Weldrims**

TITLE/TYPE: *Caminus Displodi*

KNOWN HISTORY AND/OR HABITS: Goblin chimney sweeps perform a simple but vital service. Entering a mortal home through the chimney, they furiously sweep and dust as they go, driving as much soot and ash down the flue as possible. This is blown into and thrown about the room, and finally spread all over the house. This is one of the least creative, but most effective, of home-fouling techniques. Yet the Chimney Sweeps Guild, also called the Auncient Ash and Dashers Society, is perhaps the oldest and most long-honored guild on record. Not utterly lacking in creativity, these goblins will often fill a bucket with ashes and place it delicately over a door, paint sooty mustaches on sleeping humans, or fill beautifully wrapped gift boxes with ash and woodchips on Christmas Eve (keeping all the real presents for themselves). A lot of work? Indeed. But they think it's worth it.

INDICATIONS OF PRESENCE: A sparkling clean chimney and black wall-to-wall "carpeting" throughout the house.

EVIDENCE OF INFESTATION: Ashes and soot found in very unlikely places, including (but not limited to) shoes, toothpaste tubes, milk cartons, cereal boxes, spice racks, underwear drawers, and your pockets.

NAMES: # Sirincus

TITLE/TYPE: *Spolia Malcomputare*

KNOWN HISTORY AND/OR HABITS:
Sirincus is the Evaluator of Spoils. He has little direct contact with the mortal world, except when he shows up to weigh and count goblin-pilfered treasures as they are removed from mortal homes. After they are weighed, he assigns them valuable Posterity Points which can be used by goblins to bribe the Scribes in hopes of obtaining an epic entry in the *Codex*. He owes allegiance to neither Kingdom. His own entry in the *Codex* is surprisingly brief: "Put it on the scales and don't look at me while I'm working." We have learned that he is only seen in our world when a major goblin incursion is taking place, for it is then that he is most needed to count the booty as it comes in from the field. He can also carefully and accurately estimate the value of a goblin's (or a human's) own life – a very unpopular practice. When we enquired as to how much artists and scholars such as ourselves might bring on the goblin open market, he yawned mightily before wandering off to weigh Brian's impressive collection of dwarvish potato peelers.

INDICATIONS OF PRESENCE:
Corn-shaped porcelain corn holders as well as your worst china, false teeth, shoelaces, and potted meats have been hung with decorative tags recording weight, quality, finder's name, auction number, and monetary value.

EVIDENCE OF INFESTATION:
Your big toe sports a decorative tag recording weight, quality, finder's name, auction number, and monetary value.

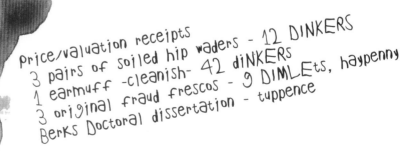

price/valuation receipts
3 pairs of soiled hip waders - 12 DINKERS
1 earmuff -cleanish- 42 diNKERS
3 original fraud frescos - 9 DIMLEts, haypenny
Berks Doctoral dissertation - tuppence

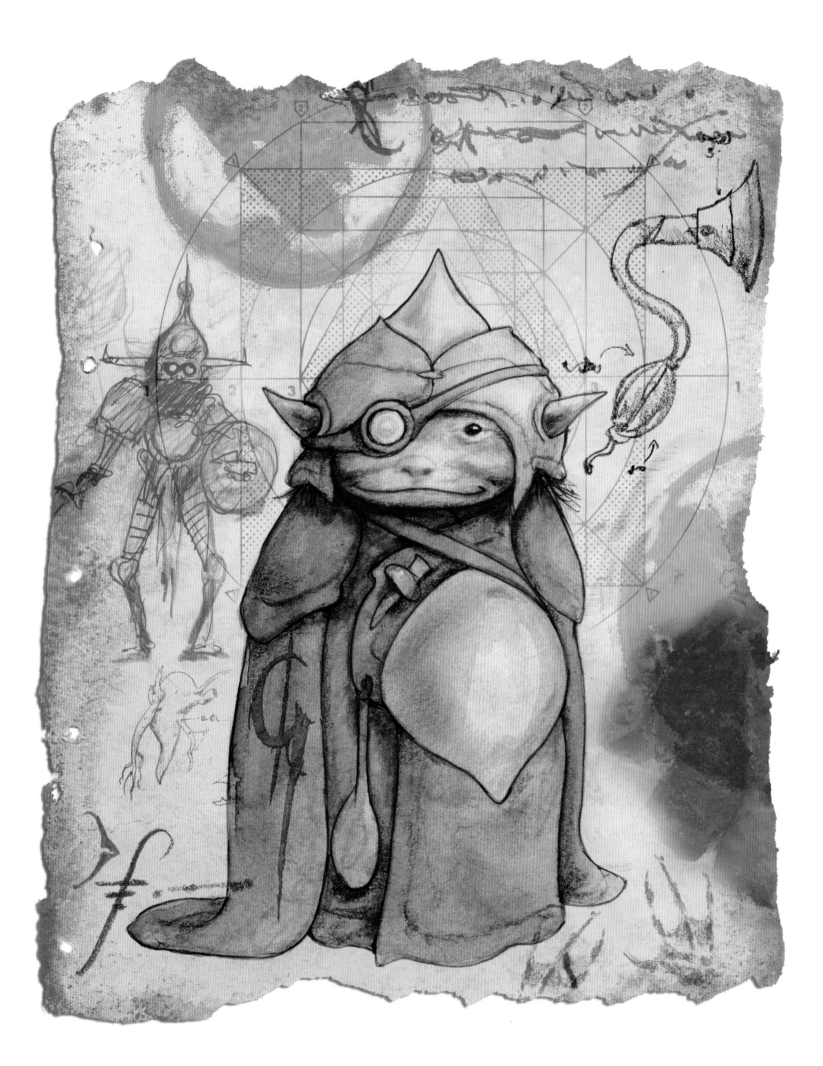

NAMES: # Aggat

TITLE/TYPE: *Saxum Pisum Incovenientum*

KNOWN HISTORY AND/OR HABITS:
A shy, quiet, and generally unmotivated goblin who tries to go about his work as inconspicuously as possible, Aggat is a stone flinger who places small, nearly invisible pebbles inside mortal shoes. This may seem a small matter, but his previous occupation was far worse. His ancient task, seldom called for in these modern times, was to hurl the unpleasant goblin-bolt at humans as punishment for some terrible oversight in respectful inter-realm protocol. Nasty little bits of sodden bread with a rock hidden inside, goblin-bolts differed from the far more dangerous elf-bolts. Instead of paralysis, goblin-bolts induced a severe pinky-finger cramp that might last anywhere from ten minutes to a whole hour. Few mortals these days could survive such torture, but Aggat amuses himself with the rock/shoe/pebble game as a reminder to mortals of what could have been, a hundred years ago, an extremely nasty (well, semi-nasty) goblin punishment. If caught in the act of putting the pebble in your shoe, he will immediately ask if you would like to wear his helmet. You *must* refuse. This will infuriate him but our world, for the moment, will be safe.

INDICATIONS OF PRESENCE: Pebbles found in shoe.

EVIDENCE OF INFESTATION: Lots of pebbles found in lots of shoes.

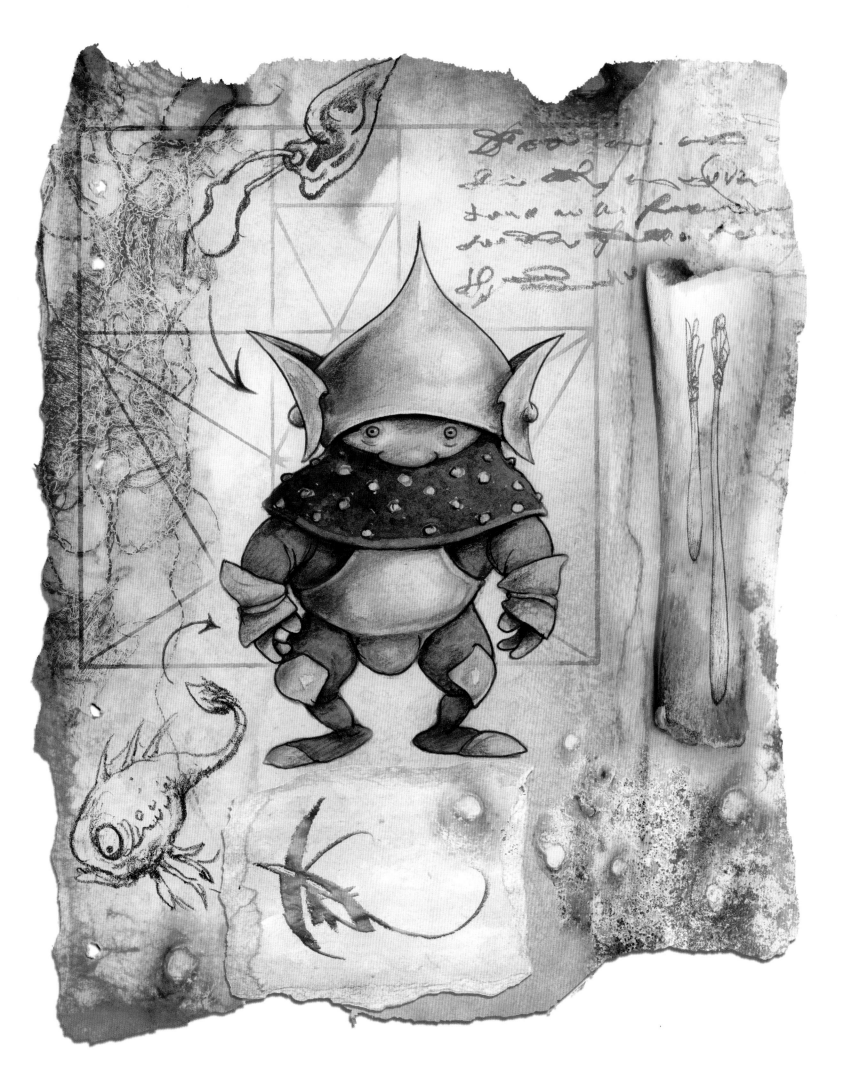

NAMES: # Haamspray

TITLE/TYPE: *Auris Auris Malidictus Maledictum*

KNOWN HISTORY
AND/OR HABITS: Common, cruel, and merciless, Haamspray is the goblin of fluctuating air pressure. An avowed enemy of the inner ear, he rapidly changes low-pressure air to high, or high-pressure to low, causing extraordinary discomfort to mortals at any altitude. Little is known of his history in Mephistis, where he makes his home, but payroll records for the Young and Promising Goblin's Academy (colloquially called the "Slappy Hut," and where he apparently worked as a crossing guard for several years) show payments to him.

INDICATIONS OF PRESENCE: Painful popping within the canals of the inner ear.

EVIDENCE OF INFESTATION: Massive explosions occurring on either side of your brain, and all the air has been let out of your car tires.

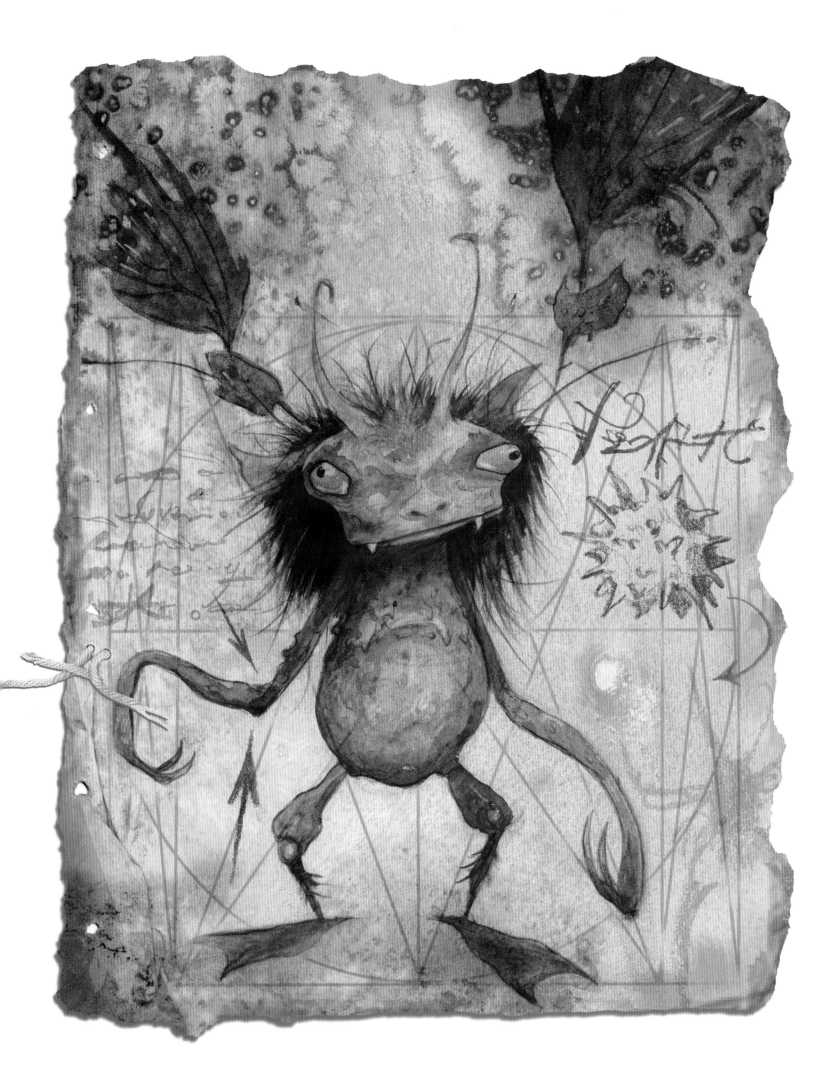

NAMES: 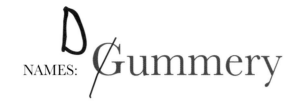 Gummery

TITLE/TYPE: *Dentalis Abductus,* or Blancette Nabber

KNOWN HISTORY AND/OR HABITS: Sadly, the "Tooth Fairy" is none other than this meticulous ivory-loving goblin. While mortals sleep, he polishes their teeth with a specially-designed brush (called "Sylvia") in the hope that he might one day add some of their "blancettes" (as he calls them) to his impressive collection. He is well armored, in case a mortal should bite down very suddenly while he is still at work.

In the Goblin Realms, ownership is established by either polishing or tarnishing. "He who cleaneth or besmircheth a thinge owneth a thing" goes an ancient goblin credo, and this is doubly true for Gummery. Therefore, if he catches you polishing your own teeth with your greatly inferior brush, he will immediately cast the offending dental instrument into the nearest toilet. When at home, he is High Keeper of the impressive Cabinet of Man-Ivory (more a drawer, really) which is filled with his spoils and open for public inspection every third Thursday during the month of Fellagash. Safely kept within the Cabinet and secured by a tiny loop of dental floss, each tooth is labeled with a name ("little biter," "pale gnasher," "candy crusher," "Abigail," "Hans von Bitey," "Tootie") and identified by source, quality, and carat weight.

INDICATIONS OF PRESENCE: A toothbrush found in the toilet, often with a hastily scrawled note attached: "Don't give up your day job!"

EVIDENCE OF INFESTATION: Every toothbrush in the house missing and several of your teeth loose or stolen. Catalogue numbers carefully stenciled onto your gums.

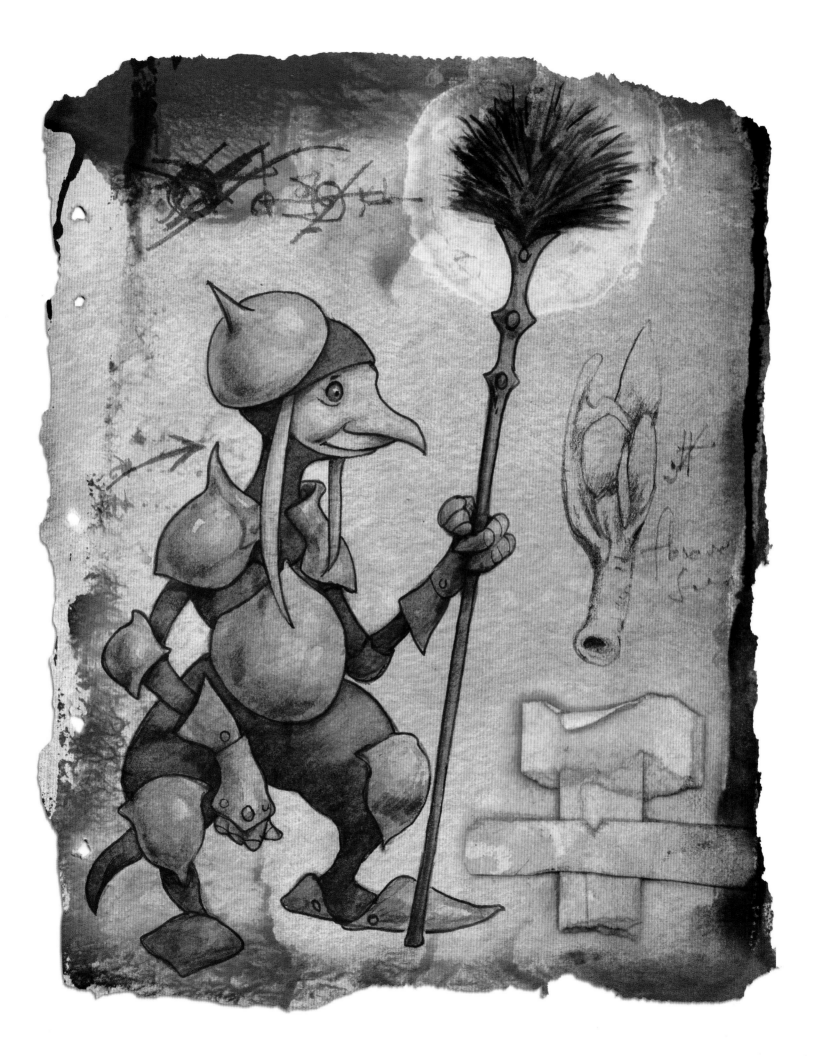

NAMES: # Passil

TITLE/TYPE: *Fruges Vitium Epidurapidum,* or The Fruiting Blighter

as usual, Berk way off
Passil is the Blighting Fruiter

KNOWN HISTORY
AND/OR HABITS:
Passil brings all living things to premature fruition and so is much despised among goblin romantics. His mere presence below a balcony accelerates the natural cycle of goblin relationships. Such "romances" normally run their complete course from formal courtship to the inevitable ugly break-up in four days anyway, but with Passil's help, this process can be reduced to a single morning's unpleasant breakfast conversation.

In our world, his impressive ripening powers are used to ruin fruit overnight. He accomplishes this by simply pressing his thumb to the skin. His vengeance is immediately incurred by mortals who neglect their houseplants. Upon them he bestows unsightly and terribly-timed pimples, blisters, and angry raised skin afflictions that instantly appear upon the face, hands, and elbows. This he does by use of his Poxing Cloth, which he lovingly wipes across his victim's skin to produce the desired effect. When the rag is drawn away, it leaves behind a field of red and purple pimples, each already swollen with a full payload of greasy malificence.

INDICATIONS OF PRESENCE:
A face full of new pus-filled friends, or one enormous blemish that proudly occupies the place on your face most likely to catch the light.

EVIDENCE OF INFESTATION:
Pimples and wens which appear swiftly all over the body. Also found on pets, children, postmen, and even on the face of the grandfather clock. All houseplants have been carefully repotted, watered, and given a chocolate.

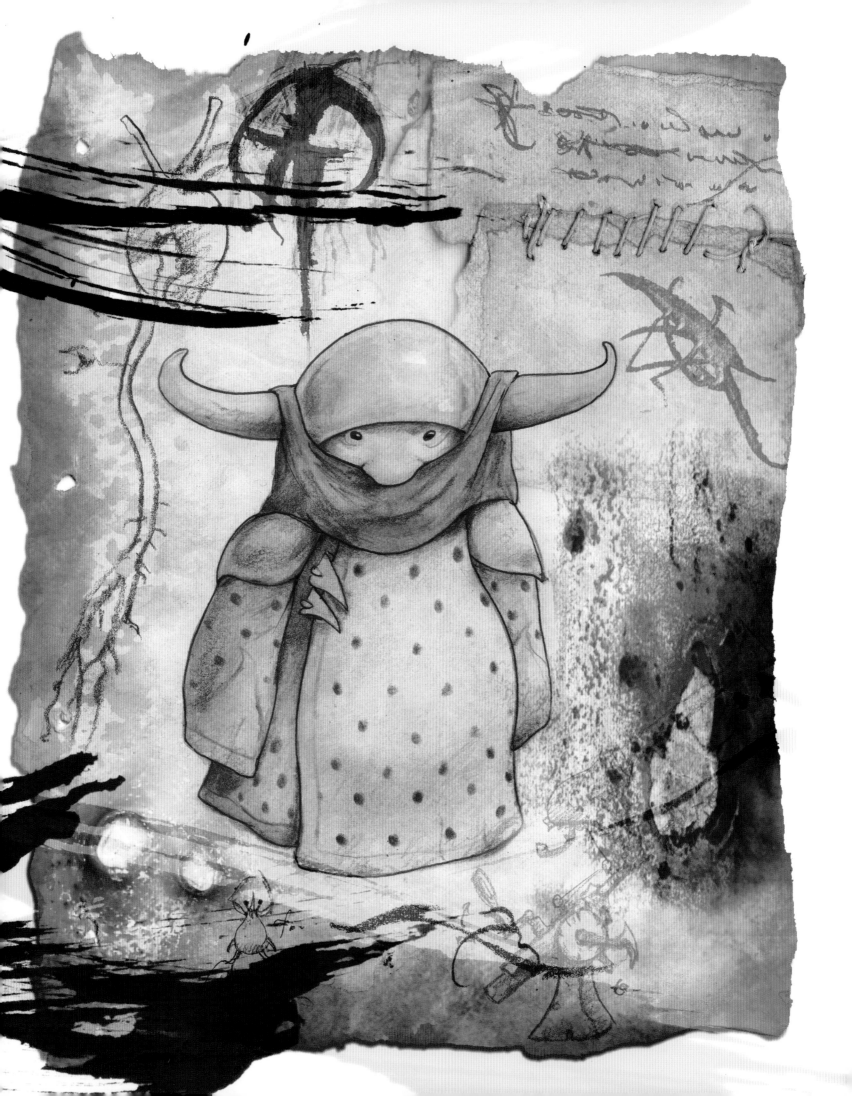

NAMES: Oorudun *the stupid!*

TITLE/TYPE: *Noctiuagus Rorere*

KNOWN HISTORY
AND/OR HABITS:
Called the "Trumpeting Terror of the Two Kingdoms," and the "Dulcid Dogge," Oorudun is one of the Roaring Boys, or Long-Gulleted Goblin Roaratorios, and is the most famous of the Night Growlers. He can produce the shrillest, most disturbing cry of all the tenors in the Terrible and Trembling Goblin Choir ("Auditions every second ThUrsday, everyone welcome"). He is the undisputed champion of delivering anONYMous, startling sounds in the night that mortals find so distressing. His wild WAILS MAY be heard in the attic, beyond closed windows, or even falling down the CHIMNEY. His imitation of an oncoming train is flawless: many mortals have leapt FROM THEIR beds out of a dead sleep, convinced that a freight engine is about to CRASH INTO THE side of the house. No mortal is ever able to forget the horrible BLAST OF OORUDUN'S voice, though it is also said that his breath (which is TINGED WITH A HINT OF moldy sponge and curried prawns) is also pretty UNFORGETTABLE.

IN THE GOBLIN REALms, he is the most delightful party guest imaginable: he WILL NEVER DECLINE TO regale other guests with a song or two, and his RENDITIONS OF "APRIL IN PARASITES" and "I Like Lewd Storks in June" are BELOVED GOBLIN COCKTAIL-HOUR favorites. Recently — in addition to BAYING BENEATH THE WINDOWS OF many sleep-deprived mortals — he has SUNG THE LEAD ROLE IN THE FABULOUS Malkin Music Hall production of "BANTAM OF THE OPERA," WHERE his cacophonous and heartfelt crowing BROUGHT THE HOUSE DOWN. LITERAlly.

INDICATIONS OF PRESENCE: Nocturnal howling, barking, shouting, crashing, and other night "music."

EVIDENCE OF INFESTATION: All the above occurring over several nights in succession. Also, missing Rogers and Hammerstein scores and breath mints.

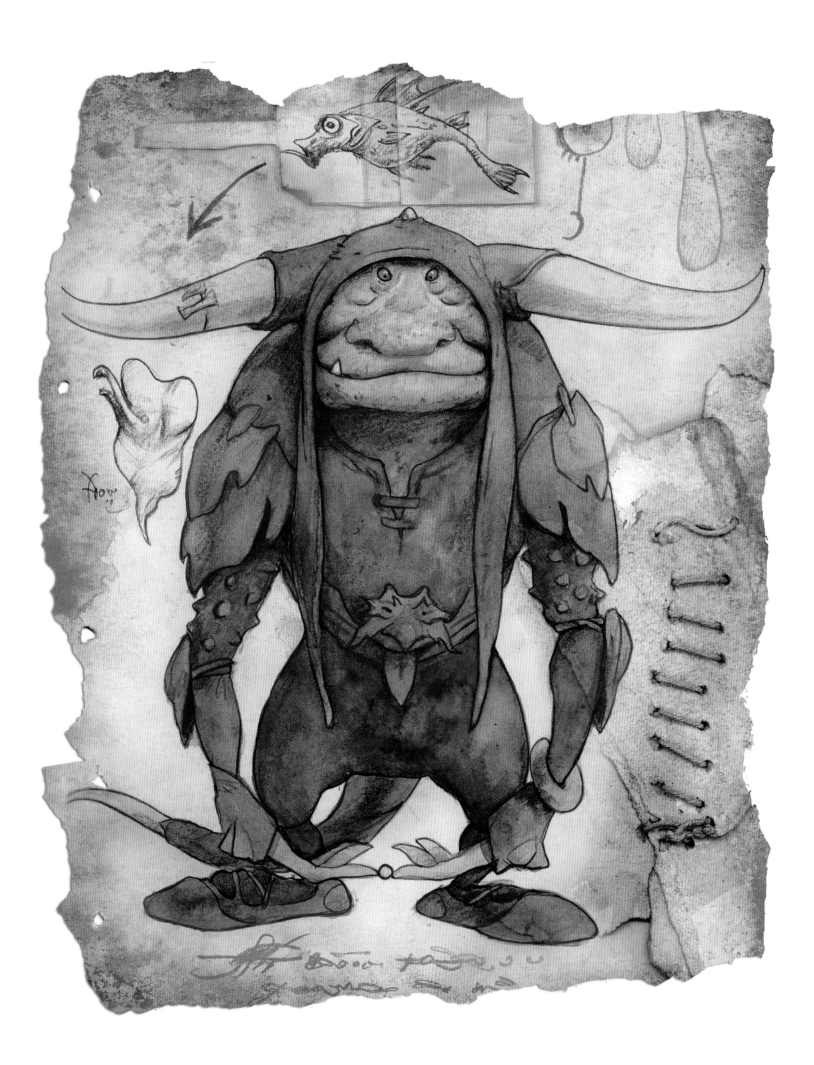

NAMES: *Canniken*

TITLE/TYPE: *Heraldicus Vaporus Blasphemi*

KNOWN HISTORY AND/OR HABITS: In the *Codex*, a long and doubtful history of Canniken has been recorded. Of this tiresome ramble, a few entries may actually be reliable. In addition to founding the famous Floating Academy, Canniken has served as the herald to the Royal Palace of Mephistis where he swiftly rose through the ranks to become Keeper of the Great and Puissant Pooting Horn of Goblin. Tradition demands that the Great Horn be sounded once a year, when the goblin nobility all descend upon the palace of Mephistis for the renowned Feast of Felicitous Famishments, where the most delightful delicacies are set before the Court on a service of the finest wormwood and bathroom porcelain.

As if this were not entertainment enough, we have discovered that Canniken spends much of the rest of the year offending unsuspecting mortals by crouching beneath their furniture and blowing on his horn such tunes as "Brownie with the Naughty Bottom," a favorite goblin drinking song.

This goblin was a frequent visitor to our lab, although he long went undetected owing to Mr. Froud's enormously starchy diet, so high in the vile and legumaceous roughage he gathers on the moor and insists upon eating each day for breakfast.

INDICATIONS OF PRESENCE: A subtly offensive odor dancing through the room, accompanied by brief melodic popping sounds with no obvious source; or a single trumpet of stench, which lingers long enough for you wake up and realize something is rotten in the state of Denmark.

EVIDENCE OF INFESTATION: Choruses of putrescence and incessant percussive explosions heard billowing behind curtains, beneath chairs, under the dog, or percolating around the elderly generally. Difficulty sleeping and breathing. Also, dinner guests who quite suddenly retrieve their coats, offering the flimsiest of excuses for their hasty retreat.

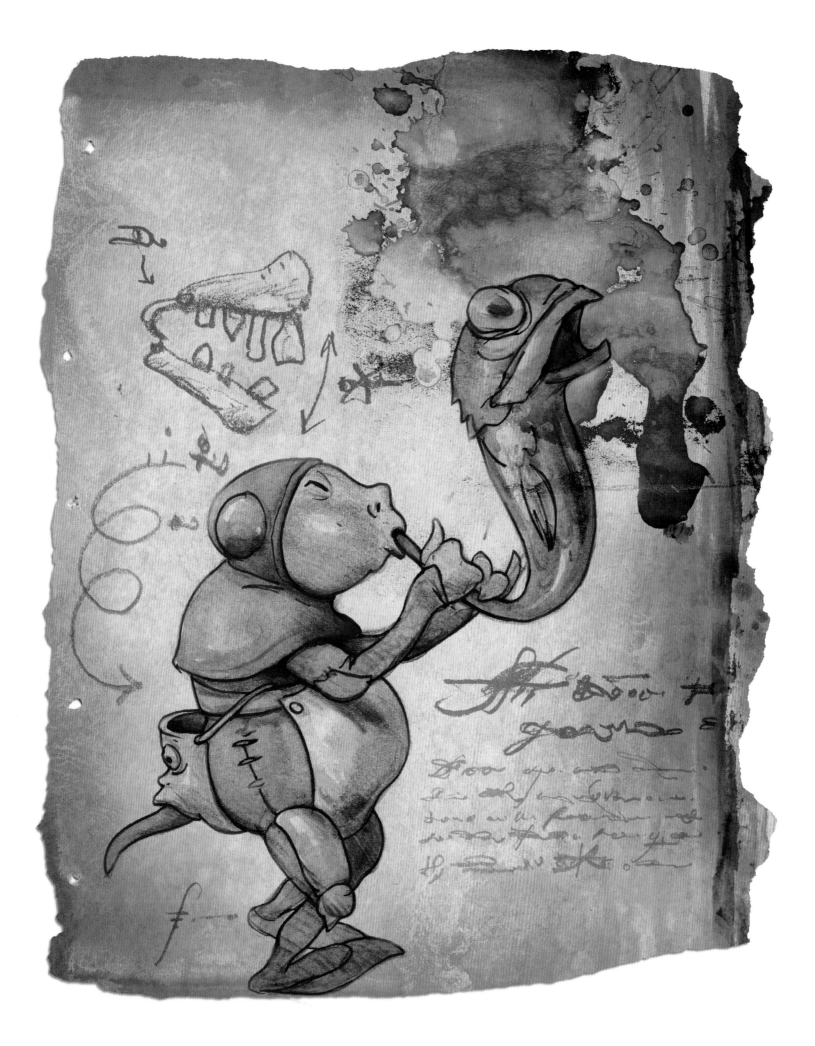

Part II

THE GOBLIN ALMANACK
In which numerous cultural curiosities are exposed in all their calendric decrepitude.

As our study of the goblins continued, we quickly noticed that certain kinds of activities (the spreading of wens, for example) seemed to be more frequently practiced at certain times of the year, some corresponding with our holidays. The *Codex* appeared to confirm these ritual patterns, but it is a complex subject and once again we found the pages of the index missing (in their place: three pages of sale items from a nineteenth-century Scottish "brew your own gruel" catalogue). Our theory was confirmed by Gargle's repeatedly asking us to release him, citing as his excuse a most dubious collection of holiday observances. Finally, he consented to reveal a few of the vagaries and celebrations that mark time through the goblin calendar year.

With obvious pride he showed us pages in the *Codex* that I had failed to discover on my own. Here were festivals and feasts, "floaters" and "sinkers," and month after wretched month of madness and malfeasance, a fair amount of it occurring at the cost of mortal peace and quiet.

❧ GLAZIERS

Roughly corresponding to our January, this is a month of visions and spectacles in the Goblin Realm. "Busy, busy time for goblins," Gargle tells us. During Glaziers, goblin designers, scientists, and ministers of the Cabinets of Curiosity are buzzing with preparations for the coming year's raiding of the mortal world. Newly-invented Devices of Mayhem and Diversion are subjected to public scrutiny; favorite sacks for stolen goods are repaired; spells are sorted; plunder carts and intra-realm conveyances are tuned and camouflaged; tail-hair is decoiffed, re-loused, and untidied.

1ST NEW FEARS DAY

Also called "Orbglam," meaning "Show Me!" or more precisely "Put that in my eye," this is the day of the annual Glorious Goblin Exhibition. On this day, all new devices designed to torment mortals in the coming year are presented to an anxious goblin public. These creations are the subject of much speculation and rumor until the moment when the tattered curtains are drawn aside and their wicked cleverness is revealed. Of course, not all of the inventions are clever at all. Consider the Giant Mechanical Fecund Finger of recent memory, which was met by boos of disdain when first exhibited and has never to this day invaded even a single human nostril. Variations on the theme of Cat-Poop Rocket remain perennial crowd-pleasers, however.

11TH HOG MANY DAY

On this day goblins delight themselves by visiting mortal farms, releasing all the pigs, and leading them to the nearest train station, where they are all purchased first-class, one-way tickets into the city. No goblin will speak of what happens next, answering only, "What a pig does downtown is its own business and none else's."

20TH AGUES EVE

Young goblin maidens (called "Sluggers"), by observing certain hallowed rituals before bedtime (including hanging upside down by their ankles and swallowing small stones called "pebbling trifles"), are guaranteed that they will dream of their future husbands. Such dreams generally take the form of nightmares and slovenly visions, which perhaps explains why goblin maidens only celebrate this holiday once before abandoning such "foul ancient custom" for more modern and practical pastimes, such as clubbing male goblins over the head with the heavy yet deliciously flaky "mother's helper" (a club made of pressed fish), and dragging them home to meet their parents.

❧ LYMUS

Vulgarly called FIBRUARY, or the Moon of Deceits. A celebration of lies and misnomers culminating in the abhorrent (and often actionable) Feast of Slanders.

15TH PRESENT DENTS DAY

Coinciding with our Presidents' Day, this is a kind of competition, as might be guessed. The dents submitted for consideration may be in any medium and delivered in any manner. Creativity counts, so the tired theme of "lump on the noggin with a blunt instrument" will never take anything higher than a fourth-place ribbon.

17TH FESTIVAL OF DENYATORIO BEGINS

On this day, loud cries of "He did it! He did it!" ring across the goblin world. Well of course he did. The days following the beginning of Denyatorio are each spent in different, but obviously related activities such

as burning and eating evidence, and the fine art of evidence arrangement, which is just like flower arrangement, but not so pretty.

❧ MARCH !

Apparently deriving its name from our month of March, this is an arduous moon of seemingly endless parades promoting the exploits of the various goblin guilds. Tradition demands that elaborate floats be constructed from materials stolen from mortal homes, and covered with flowers. However, most goblins detest flowers, so the floats are instead decorated with toenail parings, which goblins dutifully collect all year long until the beginning of this month, when they are glued with hot pitch and warm earwax to their favorite floats. Goblin floats are judged in the following categories: "Best" Smelling (this is, of course, relative), Slowest, and Most Likely to Spontaneously Combust.

7TH SNORINGLE

"Ho, Ho, Ho! Cheese, Wind, and a Pillow!"
On this day, forty-two years ago, the famous Sleeping Goblin, Krebira, briefly awoke. This well-beloved goblin lord woke from an impressive slumber lasting one hundred and three years and seven days. Upon waking, he called for cheese, farted mightily, then rolled over and went back to sleep. He is sleeping still. On this day in his honor, goblins pilfer as much down bedding from mortal bedrooms as they can find. Very quiet pillow-fight tournaments are then held, followed by lovely naps for all.

17TH SLITHERINGTIDE

Every year on this day (our St. Patrick's Day) since the fifth century, daring goblins try to smuggle snakes back into Ireland by hiding them in long thin suitcases, or secreting them on their persons in the most absurd places imaginable. They have never been able to get the poor reptiles past airport Customs, but they seem to enjoy trying.

31ST FLOATERS DAY

After having all the toenail decorations carefully removed to the Goblin Treasury, any surviving goblin parade vehicles are pushed into the river. These abandoned barges are called "floaters," hence the holiday's name. Sadly, they don't. This was once two holidays: Sinkers Day, when all the non-sinking floats were floated, and the still-observed Floaters Day, when all the non-floating floats are sunk. Like us, the goblins were terribly confused by this, and many Sinkers Days saw the erroneous sinking of many floating floaters. By rare goblin consensus, Sinkers Day was also sunk.

❧ HOGS-NORTON

Corresponding to our month of April and named for the nearly-forgotten goblin god of dichotomies, this is a month of irony and opposites. Beginning as a hushed holiday and ending with raucous stumbling around in a cheesy-twilight, yelling for supper, this month exemplifies the widely varying diversions and types of foolishness that define a goblin's absurd existence.

1st Day Off

While among mortals April Fools is a day of sanctioned jokes and tricks, this is also the only day in the calendar year when goblins are forbidden to commit nastiness of any kind, and are compelled to be nice to mortals and to each other. The result is that, in the mortal world, drains mysteriously unplug, lost pets are returned, and new chintz curtains are put up during the night by invisible hands. In the Goblin Realms, all is quiet on this day by royal decree. No new stinks are fashioned; no one's head is shaved while he sleeps; goblins even smile at each other in the street. *Creepy.*

2ND BACK TO WORK DAY

MOLDY THURSDAY

A moveable feast. Molds are grown, contests held, prizes of very poor quality are given. Prize-winning molds are distributed generously among mortal households. The usual.

23RD FEAST OF ST. GORGE

Yet another goblin dinner party. Since all festivities are held in the dark, however, there is much aggravation and consternation, as none of the food can be found. So, bonfires are built from wheels of goblin cheese (reeking stuff, easily found by its smell even in total darkness from ten miles away). Quick burning and quite runny, these festive "frommagorio flames" burn just long enough for the celebrants to find the buffet tables and chow down.

❧ MA'AMRID

While we enjoy our month of May, Goblins celebrate Ma'amrid, also called Hobby-Hag, or Creaking-Strider. This is a trying time for elderly goblin females. Upon any day of this month, one is likely to see any number of ancient goblin matriarchs being ridden through the town with wildly yelping goblin youths on their backs. The old women wear Ma'am-saddles, which are elaborately decorated with cobwebs, lace doilies, and hard candy. Once thought by some to be a mysterious fertility ritual, it is now known that the hags are only ridden for sport. Cries of "Away! Away! Wake up! Away!" may be heard at all hours during this time.

1ST MAIM DAY GAMES

Similar to our own May Day customs. Well, actually, not similar at all. Most goblin children refuse to play, because these games are dangerous and frightening even by goblin standards. A typical example should suffice: The goblins have a kind of maypole, called the "Maim Pole," or the "Rusty Cat" (because is it made of metal, and it bites and scratches). This pole is covered with hobnails, stolen kitchen utensils, and parsley (for decoration). A single doughnut is placed at the top. The first adventurous goblin youth to reach it may claim the doughnut, but must then bring it back down and give it to his parents, who immediately hurl both child and doughnut into the river. (Fortunately for the kids, goblin doughnuts are three feet across and may be used as flotation devices.)

12th FLOPPY DAY

Though shrouded in mystery, this goblin holiday is also called, "The Pendulous and Perilous Feast of Mammothrept." Little is known of its origins or observations but the following doggerel (which is chanted incessantly on this day) may hint at the festival's essence:

Floppy Day, Floppy Day
Would mother be proud?
I cannot say.

SMOTHERS DAY

A moveable festival but usually coinciding with our Mother's Day, on this day all ample-busted goblin mothers are required to chase down their children and dote on them with dangerous intensity at least ninety-two times each hour. Children are specifically asked by their fathers not to run and hide; however, most feel they must. The reason for the requirement of ninety-two times an hour is a bit complex, as most things are with goblins. Apparently, the number ninety-one is terribly bad luck for goblins, and ninety-three is even worse. Sadly, goblins can't really count anyway, so the whole business appears to be not only complicated, but pointless as well.

FELLAGASH

Corresponding to our June, this is surely one of the foulest months on the goblin calendar. Roughly translated, meaning "pull my claw," this is a time of paternal vapors and windy pronouncements. Sweeping proudly into the air from the studies and gathering dens of goblin males, foul breezes freely fly until the first day of Cankermoot, when all such activities are supposed to cease. In fact, they secretly continue unabated all year but are — except during Fellagash — blamed on the dog.

FARTER'S DAY

Held to correspond with our Father's Day, as the name indicates, this day is celebrated in exactly the same way in both the mortal and goblin worlds.

23RD BUMFIRES EVE

Ritual fires are lit in all the goblin villages on this night. These are leaped over by all goblins wishing to be "blessed and besmirched." Sadly, goblins (who are flat-footed for the most part and are miserable leapers) can never remember which foot to jump from. Most often, they land on their bottoms in the midst of the burning heap (hence the name "bumfires") to wild cheers. Indeed, any goblin without a blackened bottom by the end of this day is considered cursed, and worse, unfashionable.

24TH BUMSPLOTCH DAY

Sooty-bottomed and giddy from the previous evening's activities, goblins spend this night sliding across the linoleum floors in mortal kitchens, spelling out foul phrases and blackening them with their ashen posteriors.

CANKERMOOT

During this month (our July), goblins display their physical afflictions with enormous pride and audacious spectacle. Special glasses are worn throughout the month so that even the smallest pimple may be clearly seen and appreciated. Certain days of Cankermoot are dedicated to particular kinds of pustules and blemishes. No doubt arising out of an altruistic goblin desire to "share the wealth," mortals often find themselves the rueful recipients of many nasty skin afflictions during this time.

6TH WEN-DAY

Lovely Wen,
rise you here
to blotch the skin
and bring good cheer!

Yes. This is an entire day dedicated to the honoring of the wen. Wenish wines are drunk. Wen-tarts are devoured with special glee. Wen dances are footed fleetly. Wen-songs are sung. Wen will it end? On Kreptimus.

20TH GATHERING DAY

Newly-risen mortal skin afflictions are harvested and carried as trophies back to the Goblin Realms, to be installed in the Museum of Blemishes, where (as the advertisement states) "Each ripe pimple and drooping skin tag is catalogued, studied, and adored."

31ST Kreptimus

This vile month's revels end with the Festival of Infection. More unpleasant than you can possibly imagine.

GROTSUNTIDE

The long warm days of our August are much revered in the Goblin Realm, for it is then that all the slime sleeping at the bottom of mires and fens begins to ferment and rise to the surface. Once risen, such substances are collected by the goblin grot-skimmers and are then blended, distilled, and stored in anticipation of a long winter of tormenting mortals. This month begins a season of strange potion-making in the Goblin Realm. Grotsuntide ales are known for their vile and heady froth, which if carefully removed, can make an excellent aftershave — or glue.

10TH SEARFEST

A cook's holiday. All cooks attending the goblin Courts have this day off by custom. On this day in the year 43534 of the Great Goblin Reckoning, Searil, most renowned of goblin confectioners, was accidentally set upon the gridiron of his own kitchen, there suffering a certainly painful but also undeniably ironic death. On that same day, he was beatified, embalmed, and presented to the Court with parsnips, celery, and an aspic and orange glaze.

20TH BLOTKREPFARK

A day of pleasure and challenge. Complex in its construction, this is a difficult word to translate. It may mean "Bottoms-up," which among goblins is both toast and threat; "To the depths," a reference to both drunkenness and the very efficient scrubbing of one's shoes; or, "The poodle is mine!" Generally speaking, this appears to be a goblin drinking day when last year's sludge casks are tapped and the rancid contents are splashed greedily down goblin gullets. Why or how the poodle figures in remains a mystery.

COUSIN-BETTY

A month of madness and ecstasies running roughly alongside our month of September. All the best goblin dance parties are held during the moon of Cousin-Betty. As you might imagine, these balls and parties are themed, very exclusive, and fairly unpleasant. The term "Cousin-Betty" specifically refers to a mad goblin female. Most scholars and zoologists agree that it is nearly impossible, however, to tell the difference between a mad goblin and a sane one. This explains why all goblin women may be (safely) called Cousin-Betty, and why the phrase is generally considered to be little more than a polite greeting in the goblin guides to etiquette.

10TH DOG'S BALL

The annual dance and dinner hosted by the Fell and Ferocious Guild of Dastardly Dog Riders. This is a singular event in this guild's ritual calendar, as it is the only night when they do not and indeed may not pursue their charter. Quite the contrary. Instead of chasing, harassing, and riding their dogs, the dogs are their dates for the evening. The streets are filled with onlookers who wait to see the painted pooches leaning on the proud but slightly embarrassed arms of their goblin companions. At the stroke of midnight, however, all bets are off, and the dogs, still dressed to the nines, flee the Goblin Realm chased by saddle-carrying members of this curious guild, eager as ever to pursue their quarry.

♥ MANCHEE

Our October is the Moon of Portents for goblins. Soothsaying and divinations are widely practiced and the Augur's Guild enjoys a very brisk business during this time. Members of this guild are paid extravagantly to speculate upon the likely outcomes and possible gains of various goblin plots and intrigues. Using all manner of arcane substances, goblin augurs claim to pierce the veil of time in order pull back something their clients may need to know. More often than not, wild lies and fictions (or "swell bits" and "goodie signs," as the guild members call them) are woven from their "careful" scrutiny of mere happenstance. The geomantic "significances" of mouse droppings are *the* topic of discussion at all the goblin dining halls this month.

12TH NOAT DAY

Ring around the letter
Tomorrow might be better.
Call the Crow, and spank the mutt,
The future's stuck beneath your butt.

Noat is the day set aside for the official practice of gyroplopomancy. Letters are written on small slips of paper and used to cover the floor of the Gyroplopomantic Chamber. (Every goblin home has a room dedicated to this purpose, generally located off the downstairs bathroom.) The goblin querist (called the "Numb Stumbler") walks around in a circle until dizzy and quite nauseated. He then falls over. Whatever letters are found beneath his body are collected and used to make words which are then interpreted as omens. Typical portents are: "Ryse up, thou lout and git ye bk to bedd," or "The kwik browne fox always curdles the stewwe," or, "Tri agin later," or "Haven't you haad enuff scones???"

31ST DARK LANTHORN'S EVE, ALSO CALLED THE NIGHT OF GRIM AND DARING GOBLIN DEEDS

Throughout this night, goblins carry that most feared of all goblin devices, the Dark Lanthorn, casting Terrible Shadows over the mortal world. Under the cover of this special shade, goblins commit their most heinous acts, such as putting their dirty hands and tails all over clean mortal windows, and stealing mortal children for use as waitresses and bartenders in the least respectable of goblin milk gardens and mead halls. Lights of any kind especially annoy them on this night, and carved gourds lit with little candles absolutely infuriate them, resulting in every manner of goblin nastiness being visited upon a mortal's house (the best defense is candy hastily given out to distract them).

GOBSLOTCH

This month (our November) is named for the least honored but best remembered of the ancient goblin families. The Gobslotch clan (whose name means "Our Smell Precedes Us") were the first goblins to insist that an entire month be devoted to ritual contests involving the throwing of food at the dinner table, as well as the near-constant eating and processing of legumaceous vegetable matter for the entertainment and offense of others.

2ND ALL SOILS DAY

A memorial festival whereupon all the most unpleasant surviving clothing of the goblin's dearly departed are displayed in the public squares of goblin villages. Old goblin women finger the foul garments, foretelling fortunes and making prognostications based on the stains and blotches.

24TH STUFFING DAY

Upon this, our Thanksgiving, all goblins are reminded to "Stuff mortal turkeys with the dogge and kat."

GLADDMANO

Meaning "Happy are the Hands that Grab," this is perhaps the busiest of all the months of the year for goblins and mortals alike. Goblins are well aware of the many wonderful mortal pastimes and observances that take place during our December. Whether raiding mortal refrigerators and stealing a ham or two, chanting obscene carols in front of our homes at three o'clock in the morning, unwrapping candies and coating them with hot pepper sauce, or simply encouraging household pets to knock down and chew up our festive decorations, a goblin's work is never done during Gladdmano.

26TH EAR-BOXING DAY

A horrible holiday by all accounts. Goblins greet each other in the streets with violent slaps to the ears, then exchange gifts of earmuffs and moss-tipped swabs.

27TH POXING DAY

Ear-Boxing Day is so unpleasant that goblins need another day to recover. Poxing Day is traditionally a somber day for goblins. Families gather, stories are told, naps are taken by the fire, and scabrous, ill-gotten boils are compared, polished, and honored with quiet dignity.

So passes another year!

my bIRTHDayy!!

wishe liste
• newTROUSERS
• fruit cake
• DOMINION
• a Puppy

Part III GOBLINS IN OUR WORLD

Wherein Froud and Berk discover and elaborate on the dastardly and bizarre games, tricks, japes, and merry pastimes visited by goblins upon us in the hopes of enlightening the concerned reader as to who caused the various, and often horrible, evidences of goblin infestation within their homes, and what, if anything, may be done about it. (Here presented with many rare and hasty drawings from Froud's own sketchbook included for the purposes of identification, evidence, and general curiosity.)

By now you may be wondering if your home has, perhaps, already hosted a goblin visit. But how can you be sure? Is toast always falling butter-side down? Are bubbling sounds heard beneath the bed? Is oily smoke coming from the toilet? Something rotting in the fridge? Do you have a dog who can't stop farting? A cat who brings you dead things with tails, wings, and horns? If so, you may have a problem.

Sometimes subtle goblin evidence is erroneously explained away as mere happenstance or bad luck. Beware! The longer goblins are allowed to remain in your home undetected, the more likely they are to take up permanent residence.

The only way to get rid of these infernal pests is to take careful note of their particular habits and identify the kind of goblin you've got. To be frank, in many cases, you'd be better off moving. Short of that, the hard-won fruits of our labor are your only hope. Oh, to be sure, many dubious authors have wasted a page or two with base speculation about goblins and their ilk.[10] But they will be no help whatsoever. We shall endeavor to tell you what we know in the hope it may be of some assistance.

TELLTALE SIGNS AND UNFORTUNATE SYMPTOMS OF INFESTATION

Everywhere accidents and chaos abide, goblins are present. They thrive on causing problems in the mortal world; indeed, the hierarchy of their own world depends on their messing about with ours. They enjoy watching (from a safe vantage point) the havoc they wreak on mortals and above all desire the things we own, even the most absurd things.

Soon after our research had begun, the eggbeater from Brian's kitchen went missing. Three days later our Scribe heard from a troop of passing goblin scouts that a new temple adorned the Holy Avenue of Rescued Relics outside the Kingdom of Mephistis. The adherents to this new goblin sect worshipped a "statue" they called "The Wisking One" and prayed to it each morning with the following chant: "Braak fest es kumin, halde yur tamm hurrses!" which they recited very quickly while whirling like dervishes.

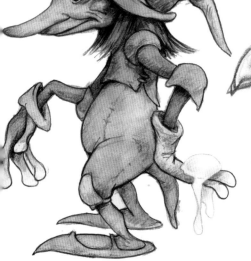

[10] *Such spurious works of "scholarship" include:* Goblins at Work and Slay *by Ingloria McRipple, MLitt.;* Slime, Stink, Stain, and Copper-Plate Engraving — a Catalogue of Victorian Goblin Calling Cards *by Ludmilla Von Claam; and Professor Athelred Catchpenny's large and utterly pointless,* A Guide to Goblin Grooming.

While goblins can certainly be vindictive with little or no provocation, for the most part the stinks and stains they leave are tricks and distractions used to keep mortals occupied or disgusted, and away from the places in their homes where objects ("bright and shinies") are being pilfered by other members of the goblin raiding party. Goblins, generally speaking, do not wish to come in contact with mortals, so they make use of disturbances to frighten and distract them.

Crews from different guilds or Kingdoms often accidentally appear in the same residence and will fight for the best spoils. Skirmishes ensue. Most are resolved by the playing of traditional games or contests and can be settled without too much violence. But every hundred years there is a Great Hullaballoo, or Goblin War, between the two great Houses. For a twenty-four-hour period, careful tallies of all stolen booty are kept by the goblin Scribes and the side that has stolen the most will rule the Goblin Realm until the next Hullaballoo. There are enormous preparations by both noble Houses and their respective guilds: plans, strategies, "engines" of war are designed and built.

Often goblin crews from different sides will fight over the richest houses; such battles are more pitched and relatively serious. Mortal homes rarely survive hosting the Hullaballoo. Such battles can affect whole neighborhoods, even cities: Pompeii has not yet recovered. In addition to homes, other mortal buildings have often been used. One previous Gobsplat (a precursor to a Hullaballoo and far smaller in scope), for example, resulted in the frightening overnight creation of the Contemporary Art Collection in the Guggenheim. Large-scale disasters such as this are common when Goblins enter our world *en masse*.

GOBLIN GAMES AND CONTESTS

A CATALOGUE OF LUDICROUS COMPETITIONS

As our studies continued, we began to see there was a pattern to the destruction caused by nocturnal goblin visitations to mortal households. Through our careful analysis of stink trails and splatter patterns, the world of goblin recreation became known to us. Goblins arrange arcane, elaborate, absurdly annoying (to mortals), ritualized contests, which are played in (and often to the detriment of) mortal homes and environments. Though the mayhem caused by goblins may appear random, don't be fooled. Even the smallest stain, when connected to a particular goblin pastime, may provide vital clues to the origin and nature of your problem. Or not. Here are a few of the more common games, along with stratagems (when they exist) for dealing with them.

Stinkimus, or Marrowbones

A farting contest (all goblins fart, of course). The first to bring his opponent to his knees wins. Difficult to detect unless the game is interrupted in progress (when there is no mistaking the smell for anything other than a visit from one's grandparents), but check the wallpaper and draperies for telltale scorching. We suggest opening all the windows and rescheduling the tea party.

Pitch Kettle

A gluing game involving warm cheese and mortal pets. The evidence of a Pitch Kettle match is both sad and obvious. We recommend bathing the pathetic animal in a warm bath of Kirschwasser, which you should heat over a very low flame while you're cutting bread into cubes. Once the cheese has melted: remove the dog, find your fondue forks, and invite a few friends over.

Flap-Dragon

A variation of Stinkimus, involving the spontaneous combustion of the opponent's clothes and eyebrows. Burnt goblin kilts and the theft of all the eyebrow pencils in the house are a sure sign.

Sock-Gullet

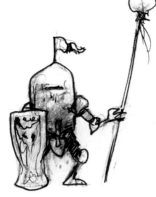

Stolen mortal underwear are eaten, regurgitated, and fashioned into unsettling sculptures called "sock-crows" and displayed around the mortal's house. First one to upset or scare a mortal wins. The residue of this game is extremely unpleasant, and the less said about it the better. We recommend lifting the garments with a set of sturdy rust-proof tongs and depositing them with all speed in your neighbor's yard.

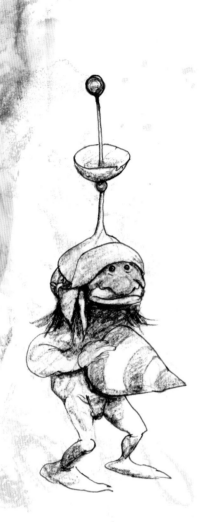

Pretty-Bird

Mortal clothing is taken from closets, combined and altered, then worn by goblins, with the most absurd creation winning. Neither Pretty-Bird nor Sock-Gullet are particularly subtle games. Once used in this manner, your clothes will be quite unwearable, due to either the *Residuum Goblinium* (a foul and sticky consequence of goblin perspiration), or the obvious fact that the goblins have altered your garment to fit their own small, unpleasant bodies. Time to shop for a new wardrobe.

Pye-Wackette

Just as it sounds. Points are awarded for distance, coverage and splatter pattern. Warm pies stolen from windowsills earn more points. After noting the above details in a sturdy, leather journal, call for the servants to clean up.

Butter-Tiles

Striking toast in mid-air with gunk, vapor, tail, or claw to make it fall butter-side down. Remove toast from floor. Scrape. *Bon Appétit.*

Kibble

A very popular cooking contest. Human kitchens are used to create goblin delicacies that are then judged by an impartial jury of innocent victims. When the entries are finished, all the human food is thrown away and replaced with the fresh goblin cuisine. Not much of a contest really, but goblins do love to cook, and they are always glad to leave a bit of their feast behind as a thank-you. Of course, there's no need to actually thank them in return. Your queasy smile will say it all.

A SAMPLING OF GOBLIN MACHINES AND DEVICES

It seemed unlikely that all the trouble was caused entirely by the goblins' busy little claws. We had long suspected they'd been making use of various mechanical devices to further their nasty plans. After surprising several goblin crews at work, we have been able to retrieve the following samples, which were carelessly left behind. Some were mentioned to us by Gargle in hushed, respectful tones. Others were gathered from the homes of unfortunate neighbors. The scrod organ was purchased in a mean-spirited and frantic on-line auction.

Barking Irons

An elaborate goblin pistol, or hand-cannon, shooting not bullets but cocktail hotdogs, with or without sauce, as it please the victim.

Scrod Organ

A musical torture device. Fish-shaped pipes emit both piercing conch-like calliope music and a rancid smell, which together are called the "Platter of Atlantean Delights." The smallest breeze will activate the organ, which, owing to its compact size, is often installed under the rim in toilet bowls, by a windowsill, or on the door of mortal refrigerators.[11]

Gammerstang

A device unrivaled for the emission of dead-mouse smell. Interestingly, it is fueled not by mice, but by cat spit, which when properly collected, treated, and preserved, retains all the moldy, behind-the-wainscoting stench of expired rodent. Shaped roughly like a viola da gamba, and played like an autoharp, gammerstangs are widely used by a variety of goblins and can, we have learned, be retuned to emit other odors reminiscent of elderly possum, deceased squirrel, and festive eggnog.

The Dark Lanthorn

Originally made to be used on The Night of Grim and Daring Goblin Deeds (our Hallowe'en), the Lanthorn holds the Dimmling Candle which, when lit, extinguishes all other sources of light, casting an impenetrable darkness over the surrounding landscape. This clever shadow-throwing device is kept in the Cabinet of Dangerous Needful Things, deep within the vaults below the Goblin Garage of Reckless Tinkering. With such a weapon, you may well wonder why the goblins haven't completely overrun our world. The answer is that fortunately, the last goblin to return

[11] *Advertisements for the scrod organ found in the* Codex *guarantee that it will "make any mortal's trip to the fridge or loo into a harrowing carnival of deep-sea sounds and smells — or your anemone back."*

the Dark Lanthorn to the Cabinet forgot to blow out the Dimmling Candle. Since then it's been too dark in the vaults to find it again.

Crustacean Compass

One of these was recovered from behind Brian's waste bin early in our investigations. Complex in design and terrible both to behold and hold (it's rather spiny), this appears to be an absolutely useless device as far as goblins are concerned, for as everyone knows, goblins hate bouillabaisse. Nonetheless, Brian and I have used it on several occasions to direct us to moderately priced fish restaurants of excellent reputation — all with respectable wine cellars.

The authors' Good Restaurant Guide >

nice things coming THISS WAY

For no apparent reason, he cuts loose the moorings of your mind, setting you adrift on a raging sea of worry, casting you upon the shoal of mental meandering and shamefully extended metaphors.

IGNABUSSE

KNOEK

Knoek the Knotter

KAARAT
A CRUEL LITTLE NUMBER

The mean-spirited goblin of weights and scales, for many long ages he misunderstood his title and thought he was in charge of standing in lines and treating reptilian skin disorders. Unfortunately, he now attends to his true occupation with a vengeance by pressing his foot invisibly onto mortal bathroom scales adding just enough weight to ruin someone's day.

ATTICUS

Noises above stairs, dragging, and stomping are his specialty. He can perfectly reproduce the sound of dragging a body over an old pine floor. In reality, all he is doing is practicing his line-dancing in anticipation of the next goblin barn dance.

INDERWINK

A wire crosser. Blame him when your doorbell rings and your toaster explodes. He is also very good at getting people lost, and at snagging a single word from a sentence as it travels through the air so that the innocent message is either totally incomprehensible or utterly offensive when it arrives at the intended ear.

YERIMI
THE GOOG

Genuinely well meaning, though his
generosity borders on the absurd.
Anything he finds in his nose or
undergarments is his gift to you.

SHEEL
THE SHOCKING TRUTH

A goblin to be feared and respected. Able to cast a brief spell upon mortal
mouths, making them speak only the truth for forty-five seconds — more
than enough time to cause a domestic or social catastrophe. Though a rare
visitor to human houses, and nearly impossible to detect until it's too late, she
can easily be conjured by foolish human phrases such as "How old do you
think I am?" or "Does this make me look fat?"

FLOOTSIM
THE LINT NABBER

Steals and hoards belly-button lint, though what he does with it he refuses to say. The *Codex*, however, lists him as renowned master of omphalomancy and a prominent member of the Augur's Guild.

YIREN
THE WHINING ONE

Utterly pathetic, she is responsible for any minor ache or melancholic mood that cannot be attributed to any actual condition. She must be quickly banished, for if left unattended, the symptoms she causes will grow out of all proportion. A good joke and three pints of ice cream are the best antidote.

A famous time-meddler.
Out of a perverse love of
seeing mortals run, which
he finds mildly humorous,
he resets clocks and creates
distraction, ensuring you'll
be late for your next
appointment.

FUWITT

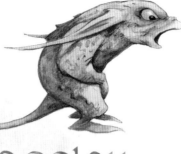

ROOLPH

Undoubtedly the finest
regurgitator of goblin pellets we've
ever had the displeasure to meet.
Unlike the better-known owl
pellets, which contain mostly
mouse and small reptile bones, the
goblin variety are more like piñatas
filled with socks, car keys, library
cards, and of course, plenty of
tasty salsa.

WET WALLY

His delight is putting a sodden tongue in
your ear when you least expect it. Totally
disgusting and yet curiously stimulating.

FOLLIMAL
THE GRIM CRIMPER

Prides herself in the ability to make any mortal's hair look absolutely ridiculous by morning. Her skill is such that no matter what implements (hair dryer, brush, garden rake) you avail yourself of, it will only make it worse.

SOLIN

Using his syrupy brush, he paints high-traffic surfaces in mortal homes — tables, counters, doorknobs — making them sticky beyond belief. There are neither stains nor smells associated with his remarkable gift, just a persistent, inexplicable stickiness that lasts for as long as you keep the furniture.

¡ loves 'er!

BLENDON
THE SMUDGER

As his name implies, he revels in streaking and besmirching newly-cleaned windows. Recent evidence suggests that these smudges serve as a kind of signal to other goblins. What they may mean remains, like the glass, unclear.

SYSTER
THE MIGHTY MICTURATOR

Known for her daring, and bestowed of an impressive aim, she leaves her redolent calling cards in the very center of expensive imported carpets, in the cat's water bowl, and on the pillow of the head of the house.

Utterly and completely harmless, Bleenque nonetheless terrifies mortals by appearing out of the corner of their eyes (or behind them in the mirror) with an unsettling frequency. He is most likely to strike when you are in the house alone. Impromptu pizza parties or spontaneous laughter will nearly always banish him.

BLEENQUE

mr Fraud him bad drawer. me draw more better

PHALACIN
THE ROOF RIPPER

On windless nights he pulls shingles and tiles from the roofs of houses.

DIGGAL

Will suffer no food to be left unburned. His arrival is heralded by several batches of blackened cookies, but by the time of a full infestation, every part of the Sunday dinner — even the ice cream — is burned to a crisp.

Visits the refrigerators, pantries, and cabinets of humans and quickly hides any item looked for by males of the household. She has never been known to hide an object from a female, however. Her chief delight is listening to the ferocious fights that immediately follow her rapid uncloaking of the "lost" item (which she always places *right in front* of the refrigerator) as the lady of the house impatiently pushes her husband out of the way to find it herself.

OSURITTA
THE HIDING ONE

KNIHIL
GOBLIN OF COMFORT

Shyest of all goblins, she does nothing. Really! Nothing. When arriving in mortal homes, she sits in the corner and watches quietly, whether there is anyone home or not. She may occasionally adjust the thermostat to 72 degrees, but otherwise, she just sits there, staring.

VENNH

One of the infamous Slackyng Boys, very common and thirsty goblins whose job it is to eagerly drink the contents of milk and juice cartons, leaving only three drops for the next person, before carefully replacing the container in the refrigerator. Will also arrive to empty your pen or printer of ink at the very moment when you most need it.

this way now

REDGE
THE WEDGER

As his name implies, he tucks a skirt up into women's underpants just as they are leaving the house. He is no kinder to men, whose shoes he festoons with bathroom tissue.

OUK
THE SPIKED

Uses his Smicking Stick to bludgeon mortal legs and feet to sleep. He then wallops them again to wake them, causing that awful, painful, prickly feeling.

NANTUS
THE HOLY ONE

He harbors a terrible ongoing feud with moths, which he sees as "damned usurpers." Nantus puts holes in mortal clothing, and then leaves a beautifully calligraphed note reading "We did it. — the moths." All this is done for his love of mothballs, which he enjoys as a garnish on sticky-toffee pudding.

SUFACO
THE SLIDER

Moves the furniture, causing well-timed and highly embarrassing noises. Or, waiting until you cross a room in bad light, he will push a piece of furniture one inch from its previous location so that you are sure to smash a toe into it on your return.

BARKIT

The goblin of sofa sloth. Often distracts humans so the rest of the goblin crew can work undisturbed. Carefully setting the television to the most mind-draining channels, he keeps mortals glued to their seats on the couch. Sometimes he may also actually glue the couch as well, just to be sure you stay put.

FRANCHUM

Despised in both worlds equally, he is, thank goodness, the only living goblin mime.

hurrrrrry

Sleeping all day in the small gap between the mattress and the frame, these playful and vindictive goblins — for they always travel in pairs — begin their games when humans finally take to their beds at the end of a long day. Then they leap into action, positioning themselves on opposite sides of the bed, starting their infamous tug-o-wars using any blankets or sheets touching the floor. A more refined and far more annoying version of this game is played when they work together as a team, pulling the blankets to one side and tucking them all beneath the buttocks of one mortal, leaving the other person totally exposed to the chill evening air.

COVERKINS

This very nasty goblin will get behind the walls of a house and tap at the nails holding up pictures and mirrors. He never, under any circumstance, actually pushes a nail all the way out, but prefers to tap them *almost* out so that the wall hanging crashes to the floor the next time *you* close the front door.

TYNKOR

FLYRIR
THE SCREEN SPLITTER

A night-flying goblin of terrible reputation, he cuts open the window screens to better facilitate the quiet, late-night arrival of bats, surly chipmunks, incontinent raccoons, and short-tempered possums. The all-night, interspecies, high-stakes poker parties that follow are worth staying up for.

FETLER
THE FRAYER

FENOBRIING
THE BELL MASTER

It is Fenobriing who presses the doorbell
the moment you step into the tub or have
just put the baby to sleep. He can also dial
a phone with similarly cruel timing.

ROWZER
THE INAPPROPRIATE SNORT

SHNELFIG,
THE WIND RIDER

This goblin pushes your foot down
on the car's accelerator when you
meant to hit the brake. He also
enjoys riding as the hood ornament
so he can feel the wind blowing
through his wings; it's his only passion.

PAESOTT
THE BLOTTER

TREEM
THE DELETER

Uses his long nose to push your fingers to "delete" when you intend to save something on the computer.

NOERRIS

Causes fungal infections of the feet by affectionately licking your toes while you sleep.

A NIGHT GASP

Nameless and noiseless, this goblin perches on the chests of sleeping mortals, her cold breath causing night terrors.

no time to wayste

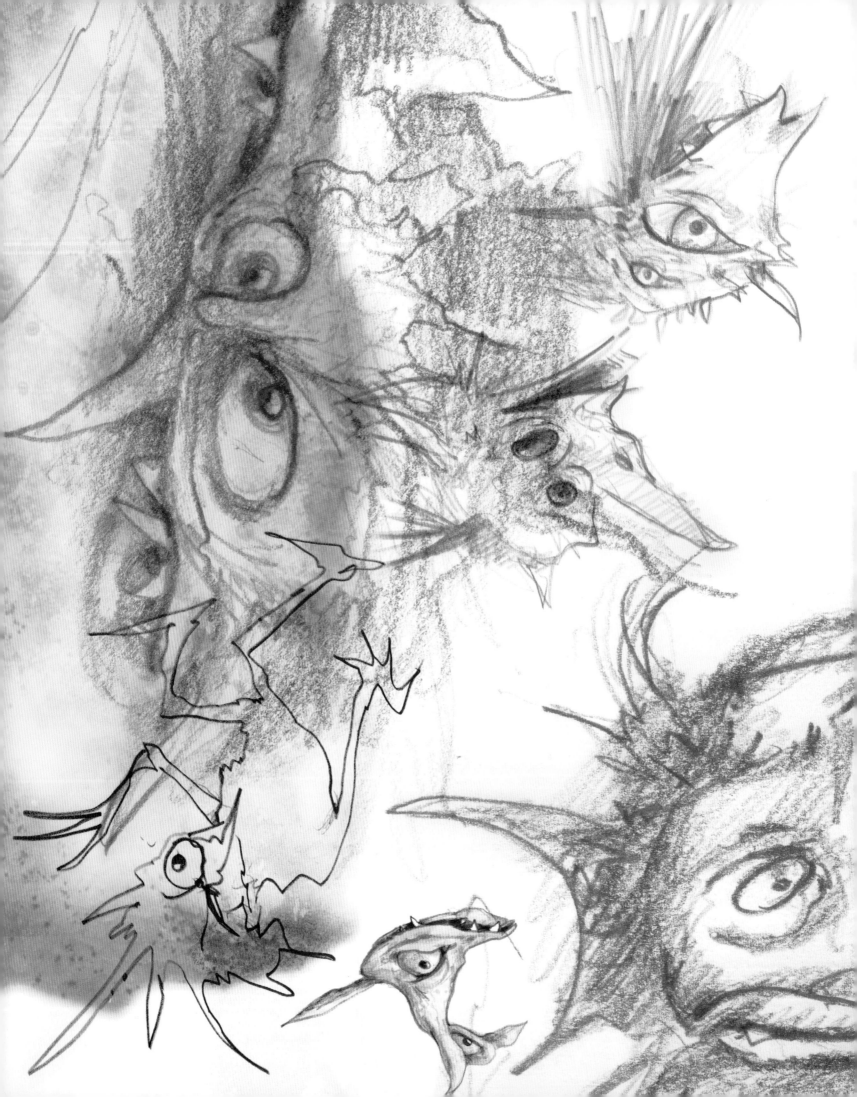

Accompanied at all times by the smell of burning plastic, Scheer disfigures and shaves the heads of children's most expensive dolls. If caught in the act, he will lie, assuring the worried child that all the hair will grow back. It never, ever does.

SCHEER

thisSS wAay.
aIMOST Tyme

Part IV

A TURN FOR THE WORSE, OR, THERE GOES THE NEIGHBORHOOD

In which Froud and Berk begin to suspect that knowledge of the Goblin Realms comes at a Terrible Price.

Dr. A. Berk
CASE NOTES

CONFIDENTIAL

Subject: Froud

Phenomena: Goblins

pretty things

2 February
Since the beginning of our investigations, Brian's condition has worsened. Two days ago he ran half-naked through the village with an oily farming implement in one hand and a sketch of a goblin in the other (the words, "It wasn't me!" scribbled below it) yelling, "Oh he's a liar, he's a liar! They're a-comin' I tell ye, they're a-comin!" Normally, such behavior would not trouble me greatly, but this occurred before breakfast! Brian's drawings grow more hurried and desperate as more goblins move noisily through this house, and indeed, through all the surrounding villages.

4 February
All evidence points to trouble. Goblin incursions continue to worsen in both frequency and scope. Not a single shoe left in the house. Butter rancid. The now be-cheesed dog is furious with us, and Brian's wife has quit the house and is now residing above a piano bar in Moretonhampstead. All our evidence indicates the time of a centennial Great Hullaballoo is again at hand. This recurring event is the only time during which

7 February
Gargle begins to answer every question in a friendly, relaxed manner and without any offensive gesturing. WHY? He acts as though he wants us to know these things. He takes an interest in the publishing process. How many copies of the book will be printed? Will they be kept in many mortal homes? WHO IS OUR EDITOR? What is her address and telephone extension? He wants to help. Should we BE WORRIED? Must begin translations of the Goblin Confounding spells hidden deep within the Codex. Shadows below the stairs are lengthening.

8 February, 11:41pm
CODEX STOLEN!
GARGLE GONE.
We now see it was all too easy. Surely we never really had the power to keep him. WE ARE FOOLS. Many notes deSTROYed or stolen. Thorough search of the downstairs bathroom where Gargle was kept turned up a scrap of paper upon which he had apparently been practicing our signatures xThoroughxxsearchxxx
WE HAVE BEEN TRICKED!! found It at last: Lost page from Codex with entry for behind toilet, "Nyargle," which we learn xxxthexdownstairsxxbaxx too late is "Gargle's" real name. MUST GET WORD TO PUBLISHER. No time to record anything but liteRAl traNslatION of his Codex entry:

very prETTyist pickture

too late

We are Nyargle, Lord of Pestilence, Herald of Grete Hullaballoo and Master of the Threshold. Always bringing Loverly Surprises for Mortals: plague, many other better tricks. Much Fun for Europe long time ago. Wait. Soon all to be ours. Fools will open the door. We are coming. We are coming. Then too much fun for you. We be laffing soon and ALWAYS.

8 February, 11:59pm

We must get out. House overrun. Now fear the worst regarding intentions of Gargle/Nyargle — and indeed, the whole of the goblin rabble. Have arranged for publishers to include an Elvish Talisman of Catastrophic Containment in each copy of this book. This powerful anti-goblin device has long been used by the good folk of Faery to keep their nasty goblin cousins out of the grove dances and away from the buffet table at the better garden parties. Hope it is not too late...

THE TALISMAN IS IN A SEALED ENVELOPE...MUST BE KEPT CLEAN AT ALL TIMES! WE PRAY THAT YOU MAY PRESERVE YOURSELF FROM THE FAST APPROACHING GOBLIN JUGGERNAUT. HANG IT MMEDIATELY ABOVE FRONT DOOR OF YOUR HOUSE TO DETER GOBLIN INVADERS.

Waste no time in displaying sigil
can say little more

SHADOWS — SMELLS — TOO MUCH

MUST PACK AND FLEE

TAXI OR CARRIAGE TO EXETER?

ALL CHEESE
GONE!
THEY ARE

ANTI-GOBLIN DEVICE

EFFICACIOUS ONLY IF UNTARNISHED

GOT GOBLINS?

- ☐ stolen nail parings
- ☐ basic to elaborate mayhem
- ☐ noisome pets
- ☐ general itching
- ☐ inexplicable stains
- ☑ frequent visits by ~~dastardly~~ *handsome* goblin scribe
- ☐ unbelievable stenches
- ☐ mysterious night noises
- ☐ rancid shoes
- ☐ befouled furniture

WWW.GOTGOBLINS.COM